Flower & Garden Photography

Derek Fell

SILVER PIXEL PRESS®

Rochester, NY

Flower & Garden Photography

Written by Derek Fell

Published in the United States of America by
Silver Pixel Press®
A Tiffen® Company
21 Jet View Drive
Rochester, NY 14624
Fax: (716) 328-5078
www.saundersphoto.com

ISBN 1-883403-65-0

Printed in Germany by Kösel Kempten (www.KoeselBuch.de)

Library of Congress Cataloging-in-Publication Data

Fell, Derek.
Flower and garden photography / Derek Fell.
 p. cm.
 ISBN 1-883403-65-0 (pbk)
 1. Photography of plants. 2. Photography of gardens. I. Title.

 TR724.F43 2000
 778.9'34—dc21 99-086235

Flower & Garden Photography

Derek Fell

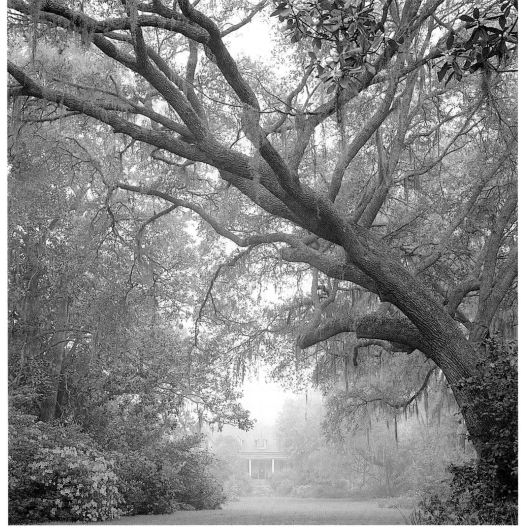

Magnolia Plantation, South Carolina

About the Author

Derek Fell's first book on photographing plants and gardens appeared in 1980 and sold 40,000 copies worldwide. He has traveled widely throughout North America and Europe, as well as Africa, China, Japan, South America, and New Zealand, and has created a stock photo library of more than 150,000 images. He sets specific creative goals, "firing arrows" with his camera that strike their targets: an underwater garden in the British Virgin Islands; a rainforest garden in lion country, South Africa; an alligator-infested swamp garden in South Carolina; a wildflower garden in the Sub-Antarctic inhabited by sea elephants and royal albatross; gardens of the great French Impressionist painters in France.

Fell's work is highly regarded by his peers, and ranks with the giants of photography, garnering more photography awards from the Garden Writers Association of America than any other photographer. He is one of a select group of photographers profiled in the *Outdoor Life* television series, "Nature's Best Photography," sponsored by Nikon and the National Wildlife Federation. For six years, he hosted a garden show, *Step-by-Step Gardening*, for the QVC television shopping channel.

His work has appeared in *Architectural Digest*, *The New York Times Magazine*, *Hemispheres*, *Garden Design*, *Woman's Day*, *Family Circle*, *Gardens Illustrated*, *Parade*, *Birds & Blooms*, *National Geographic Books*, *Readers Digest Books*, and many other publications. Fell has authored more than 50 books on gardening and travel, all featuring his own photography.

He lectures widely about "photography and gardens as art" at art museums, including the Smithsonian Institution, the Philadelphia Museum of Art, the Barnes Foundation (Philadelphia), the Walters Art Gallery (Baltimore), and the Renoir Foundation (France).

Books, wall calendars, engagement calendars, greeting cards, and art posters featuring Fell's photography are published worldwide. His photography is sold in signed editions, and his photographic art poster, *Monet's Bridge*, is displayed and sold at the Monet Museum, Giverny (France). Several solo exhibitions have featured his work, notably the traveling exhibit, *Impressionist Gardens*.

Born and educated in England, Fell emigrated to the United States in 1964 and became a naturalized American citizen. Derek Fell is married and has three children, Tina, Derek Jr., and Victoria. His wife, Carolyn, is an expert on flower arranging and a professional stylist. Their home and garden, Cedaridge Farm, in scenic Bucks County, Pennsylvania, is planted as an "outdoor studio." It has won several awards for creative garden design, and is open to tours.

David Silverman, editor

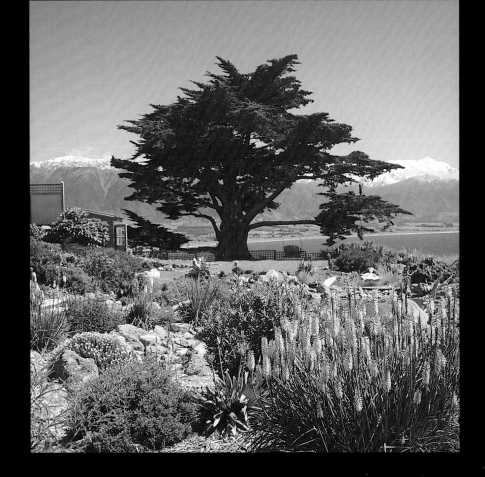

Table of Contents

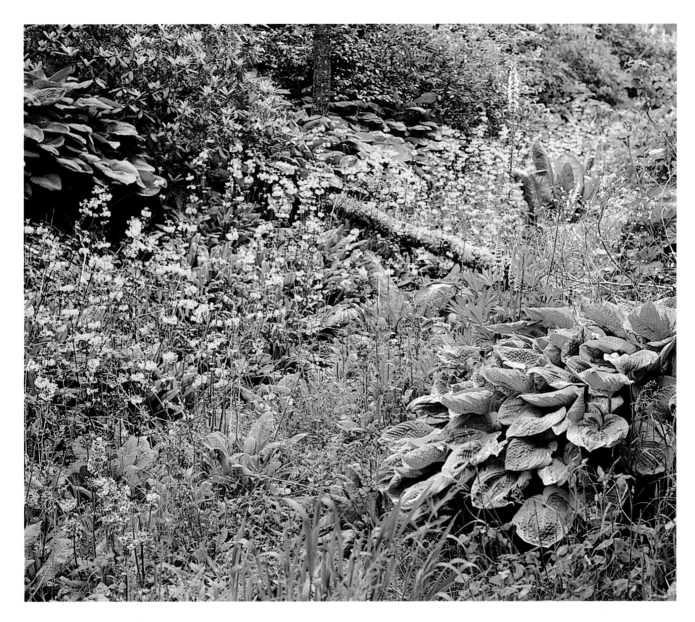

Bog gardens can be extremely colorful. This view has the extra appeal of a fallen tree trunk and bold clumps of hostas edging a colony of yellow primulas.

Getting Started

Photography and gardening are top leisure-time activities, and no two pastimes make a finer combination. Plant photography is fun, exciting, and can be full of adventure. It opens your eyes to a new world of beauty you may have taken for granted. It's a healthy pastime that is rewarding, creative, and enlightening. Moreover, the opportunities to sell plant pictures have never been better. Success does not depend on complicated equipment, a lavish studio, or a comprehensive knowledge of photographic terms and techniques. The formula for success can be a few simple, easy-to-learn basics using natural light.

All the photographs in this book have been sold for publication, and most were taken using just four fundamental items of equipment: a camera body with standard lens, a roll of film, and a tripod. Others were created using accessories such as electronic flash, filters, extension rings, bellows, wind breaks, and cable releases, but they are not necessary for quality results.

I have been able to earn a comfortable living as a plant photographer because most users of flower and garden photography, such as seed companies, garden magazines, garden-book publishers, and calendar companies, rely heavily on work contributed by an active group of amateurs, semi-professionals, and professionals, many of whom build valuable collections of beautiful pictures by photographing plants on weekends, in spare time, and during holidays. Some flower and garden photographers break into the market by first specializing in a particular plant category, such as orchids, roses, and wildflowers. Then they branch out into gardens and vegetables, for example. It takes time to build a comprehensive collection of plant photographs; creating a niche in a popular category is one way to get started.

Whether you choose to concentrate on photographing a particular plant category or spread your efforts wide into every aspect of horticulture—even if you never intend to sell your work—it helps to have a focus. Indeed, as outlined in Chapter 11, opportunities for sales are so vast that it's hard to cover all potential markets. In time, however, you will tend to settle into a niche that feels most satisfying, and can concentrate on serving that market with your best effort.

For example, a friend from Sweden takes pictures only of people in their gardens, for gallery sales and exhibition. Another friend travels the world photographing only cacti in the wild for lectures. Several others I know shoot only to sell prints for framing. My focus has always been to produce publication-quality pictures. "If I can't sell it I don't shoot it" is a

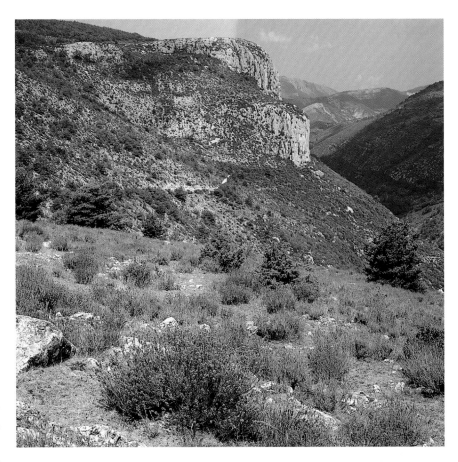

rule I have lived with during 35 years of photographing plants and gardens—except to take a few snapshots for the family album and as mementos of trips. As a consequence, I have probably sold more plant photographs worldwide than any other nature photographer. There is hardly an image in my stock library that has not been sold. This book is intended to pass along my experiences in making plant photography a pleasant and profitable enterprise, with an emphasis on creating salable work.

For the purpose of simplicity, I am assuming in this book that the reader understands basic photographic principles and techniques. For more in-depth information about specific cameras and photographic technology, read some of the other Silver Pixel Press books.

Many photos show cultivated lavender fields, but few show lavender growing in the wild. I accidentally stumbled across this view of wild lavender in its native habitat in the Maritime Alps of Provençe when I hiked a trail to explore the ruins of a medieval castle.

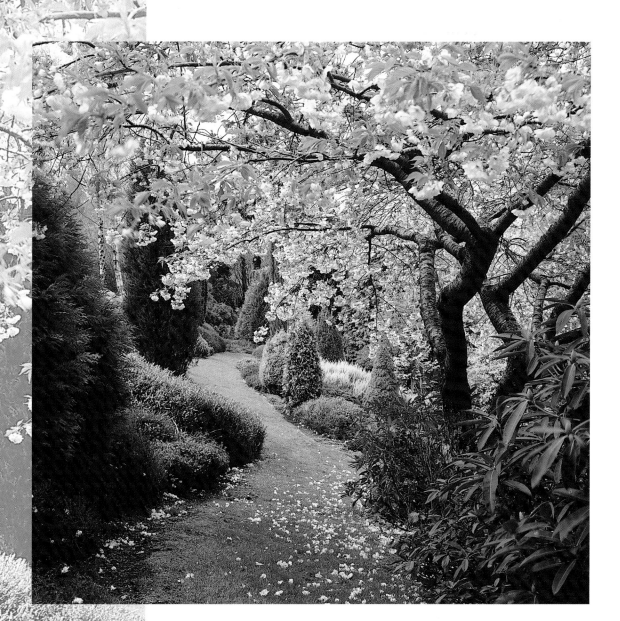

When I first became interested in photography, I thought a good photographer had to amass a lot of expensive equipment and master some complicated photographic systems. Visiting photographic exhibits looking for ideas and inspiration, I was often impressed with special effects, but all the filters, lighting equipment, and different lenses confused me. It seemed that, to be a professional photographer, you had to be more of a technician than an artist. Fortunately, something happened that changed my mind and showed me that good photography can be simple.

While working for a British advertising agency, I had to produce some advertisements for a seed company that had developed new strains of cabbage and marigolds. I needed a photographer to shoot color transparencies suitable for reproduction. The editor of a national magazine recommended an elderly gentleman: Harry Smith, a retired schoolteacher who was producing some extremely good work. I gave Harry his first commercial assignment, and I watched him in action at the trial gardens where we shot the assignment.

(Opposite page) Maple Glen Garden, New Zealand, where the seasons are reversed. Every year I travel to New Zealand because it has many undiscovered gardens and gives me an extra spring and summer season for shooting. This image won an award for Best Cover Photo when used on the jacket of *Glorious Gardens*, a book featuring photography of the world's leading garden photographers.

He showed up at the farm with little more than a roll-film camera and a tripod. The client was surprised at the lack of equipment and wondered who this character was, taking "pot-shots" of his plants. A week later, Harry showed us the pictures; I will never forget the effect his work had on me. The color transparencies were beautiful. I could not believe that such beauty had been achieved with so little effort. (Within seven years, he became a widely published plant photographer, shooting tens of thousands of images with his simple system. Shortly before his death in 1974, he was awarded a silver medal from the Royal Horticultural Society for his outstanding work as a plant photographer, and his collection today forms the nucleus of the Society's stock library, the Harry Smith Collection.) I bought the same camera and started to emulate his style because he had a way of making every plant specimen look completely natural (even if posed), and shooting gardens with not only a distinct sense of season, but also unusual lighting qualities, such as a misty morning or rainy day.

Just before Harry Smith passed away, I moved to the United States and continued to shoot plant pictures. I also studied the work of other nature photographers and over time developed a style that has allowed me to not only service seed companies wanting images for their seed packets and mail-order catalogs, but also calendar companies wanting inspirational landscapes, CD-ROM producers needing lots of "plant portraits," and even

Images for calendars, posters, and prints for framing (above) are taken with a medium format system. I use 35mm almost exclusively for close-ups and plant portraits because most publishers don't mind a small image size for these types of shots.

a steady business of limited-edition signed photographic prints and posters for framing. Over the years, I have produced more than 60 garden books and garden calendars, and lectured at prestigious institutions.

Here, then, is how it has been done, starting with basic equipment.

Camera Formats

Plants grow in some odd locations, so you must often squeeze into tight places to create the most natural pictures. As a result, equipment size and weight are vital considerations. Chasing around 1000 acres at Longwood Gardens, Pennsylvania, searching for the best specimens to photograph as I do can be tiring even without a camera. When planning equipment purchases, bear in mind that you may be carrying it around for long days! With that in mind, be aware that there are three basic camera/film formats, and that the larger the film size, the sharper the image will be for large blow-ups such as calendars, posters, and billboards.

35mm SLR Cameras

In my opinion, 35mm—the smallest of the three formats—is adequate for most pictures. My current camera of choice is an Olympus because it has a highly accurate light metering system with automatic and manual settings, and is lightweight and quiet when you trip the shutter. In addition, with its built-in spot-metering system, I can choose a precise area of the composition for accurate light metering, such as the dark trunk of a tree against a bright sky background.

It's almost impossible to shoot a poor picture with a quality 35mm camera and a sharp lens. These cameras view and shoot through the same lens and offer many state-of-the-art features. However, do not use the automatic-focus feature because flower and garden photography usually require that the focus be on something quite specific, often located in an area not in the automatic-focus system view.

These cameras are handy and so easy to operate, they are used to produce most horticultural photographs. Some prolific professional plant photographers use 35mm exclusively because there is no longer a bias among editors for larger format images as there was years ago. Most quality 35mm cameras are highly versatile and offer a wide selection of lenses. You can find many of these features in cameras from Olympus, Canon, Minolta, Pentax, Nikon, and other manufacturers.

Film for 35mm cameras is relatively inexpensive, so it doesn't hurt the pocketbook to experiment with some off-beat, creative ideas. A photographer using a medium-format system tends to be more conservative and more disciplined because of cost, and the fact that rolls usually have only 12 exposures, compared with up to 36 for 35mm.

Be sure to purchase a camera that features through-the-lens (TTL) metering, especially with off-the-film (OTF) metering. The most precise light metering system available, it measures the precise amount of light actually reaching the film's surface. My camera's metering system includes manual and automatic metering, spot-metering, and multi-spot metering. It also has a Program mode that allows the camera to do all the "thinking," choosing shutter speed and aperture settings. Compensation buttons allow for adjustment of exposure for shooting tricky lighting situations, such as a black pansy in a white windowbox, or a white petunia against a black fence.

Medium-Format Cameras

Medium-format cameras require 120 or 220 roll film and produce square (6 x 6 cm—2-1/4 x 2-1/4-inch) or rectangular images (the most popular is 6 x 7 cm (2-1/4 x 2-3/4-inch). I use the 6 x 6 cm square format.

These cameras offer a lot of advantages, especially if you intend to sell your plant photographs. The waist-level viewfinder shows the actual image area of the scene: What you see is what you shoot. (35mm cameras typically show most, but not all of the actual scene in the viewfinder.) Most medium-format cameras can be handheld at waist level, allowing you to work quickly around the subject to get the best angle. Another important advantage is that the viewfinder is positioned on top of the camera, so you look down into it. This permits you to kneel or bend to photograph low-growing plants instead of lying on your stomach with a 35mm camera.

Some models set exposure automatically and include a spot-metering mode similar to that in the best 35mm cameras. Rollei, Hasselblad, Bronica, Pentax, and Mamiya are the most widely available brands. They are relatively lightweight and, although not as light as 35mm cameras, are easy to carry and simple to operate.

35mm rectangular format uses roll film, up to 36 exposures to a roll. Cameras using 35mm film are the most lightweight and the most versatile, and many professionals use 35mm exclusively. However, image size is small, the slides must be seen through a viewer and, when a publisher has a choice between equal images shot on 35mm and a larger format, the larger one usually is more acceptable.

2-1/4 x 2-1/4-inch square format uses 120- or 220-roll film, 12 or 24 exposures to a roll. These cameras, similar to the 2-1/4 x 2-3/4-inch models, are lightweight and can be used without a tripod. This is the format most often used by professionals. Publishers like the square format because it can be used as is, or cropped to create a rectangular vertical or horizontal without much loss of picture area.

When planning equipment purchases, bear in mind that you may be carrying the camera around for long days!

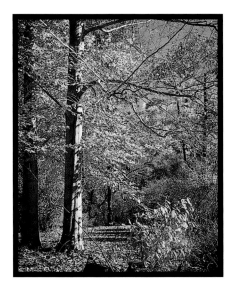

2-1/4 x 2-3/4-inch format uses 120- or 220-roll film, 10 or 20 exposures to a roll. The cameras are lightweight and can be used without a tripod.

4 x 5-inch is one large format; 8 x 10-inch is another. These cameras require sheet film that is loaded into individual holders by hand. The camera cannot be used effectively without a sturdy tripod.

How to Avoid Blurred Images

The most critical quality for selling pictures is sharpness. This is achieved several ways:

- Narrow focus: Avoid setting the lens on infinity except for grand landscapes. For sharp focus, normally it is best to focus on something definite, either in the middle ground or foreground.
- Slow-speed film: Choose 25-, 50-, 65- or 100-speed films for maximum sharpness. These are known as "fine-grain" films, which exhibit the least loss of definition during the enlargement process.
- Aperture Settings: For good depth of field (area in focus), choose aperture settings such as f/11, f/16, f/22, or f/32.
- Know your lenses: Choose a lens specific to the situation. For overall views, use a standard lens; for close-ups use a close-up lens. I prefer not to use a zoom lens to cover both distance and close-ups.
- Keep lenses clean. Wipe the lens surface with a non-abrasive, lint-free cloth. Never start a shoot without examining lenses for water spots or smudges. When poking a lens through leaves and flowers, pollen, dust, and dew can settle on the lens surface, blurring images.
- Tripod support: For crisp images, even for fast shutter speeds of 1/60- and 1/100-second, use a tripod to keep your camera rock steady.

Unlike the smaller 35mm format, 6 x 6 cm transparencies offer three times the image area, so the pictures can be viewed without a magnifier or projecting them. This definitely influences editors. Medium-format film originals are large enough for quality reproduction, even big enlargements. And the 6 x 6 cm's square format is advantageous because it allows beautiful picture compositions without having to worry about vertical or horizontal framing. Picture editors have more choices about vertical or horizontal cropping to fit page layouts, as opposed to vertical or horizontal 6 x 7 cm shots that may not have been created with cropping in mind.

I suggest that you avoid twin-lens-reflex medium-format cameras, which have a viewing lens and a taking lens. Spend the extra money for a good single-lens-reflex, which views and shoots through the same lens. The most sophisticated models, such as the Rollei 6000 system, offer manual and TTL automatic light metering and flash metering, but also spot metering so you can accurately meter specific areas within a composition, such as a darkly lit tree against a bright sky. These cameras have automatic film advance and other state-of-the-art features found on the best 35mm SLRs—including an extensive range of interchangeable lenses.

However, not every image you shoot must be medium format: I always travel with both medium-format and 35mm cameras, using the larger format only for superior images, such as calendar quality. I shoot most close-ups and garden details with 35mm, and the 35mm is my back-up.

Sheet-Film Cameras

The largest format is the sheet-film camera, sometimes called large-format. The camera/lens combination is relatively expensive and bulky, and film must be loaded into individual sheet-film holders. These cameras are used mostly by professional photographers specializing in commercial photography requiring high-quality reproduction for presentations, exhibition displays, and blow-ups such as billboards. Loading film is slow and requires additional skills. In addition, when shooting, you need a black cloth to be able to see the image—which happens to be upside-down—on the ground-glass focusing screen.

Large-format cameras are offered in three sizes: 8 x 10-inch models are complex, physically unwieldy and extremely restrictive; 5 x 7-inch and 4 x 5-inch models,

Flowers with iridescent yellow petals often reflect a strong glare that produces a false meter reading, especially on a sunny day. To compensate, the photo on the top was shot at a stop above the meter recommendation to compensate for glare. The photo below was taken with no exposure compensation.

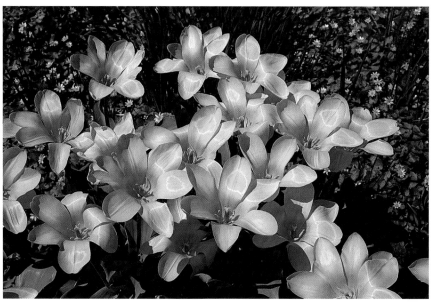

although much smaller, are still bulky and hard to use without a sturdy tripod.

A number of dedicated plant photographers use large-format for photographing gardens. They endure the difficulties to gain impressive image size. Photography sold as fine art is often shot in this format. Famous outdoor photographers such as Ansel Adams, Eliot Porter, and Edward Wesson made their names using large-format cameras, and their work has sold as fine art mainly because of the fine definition that format provides in poster-size blow-ups. Photographers who command $5000-and-more for their prints do so mostly with images produced using large-format cameras, although it is possible to create a modest income in the fine-arts world from medium-format and 35mm as well.

For those interested in this niche market, here are some tips:

• Always do your own processing (including color, preferably using color-fast Cibachrome for prints).
• Find a gallery to represent you in a location known for fine art, such as in New York City and Carmel, California.
• Produce a monograph of your photography, offered through a fine-arts publisher, or as a self-published work. If you can't manage this, consider publishing a mail-order catalog and sell direct.

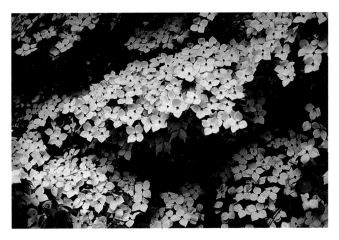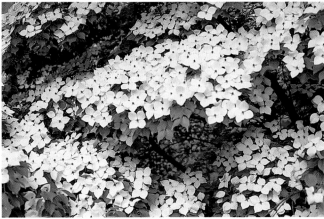

Because white flowers under bright light and landscapes covered in snow often produce strong glare, shooting at 1-1/2 or even 2 stops more exposure than the meter reading is sometimes required. These dogwood images show a dark image using the camera's automatic reading and a brighter manual image with 1-1/2 stops more exposure.

Film

It's amazing how dogmatic some photographers are about film. In recent years, I've seen brands recommended that I wouldn't use if you gave me the film. Although many companies, including Kodak, Fuji, Agfa, and Konica, among others, make slow-speed, high-resolution, fine-grain films suitable for garden photography, the only way to decide what film satisfies your aesthetic standards is to test each one under various lighting conditions (especially sunlight and shadow) and compare them. Above all, look for crisp, clear colors, good resolution in both light and shade, and—most important of all in my opinion—bright, natural greens that do not turn dark or "muddy" in low light.

Always consider whether you might need a duplicate of any images you shoot. If you might, make an "in-camera duplicate": Shoot additional identical exposures of the scene because it is more expensive to have duplicates made once the film is processed, and the quality may not be the same. I sometimes consider an image to be so valuable that I take an entire roll of 36 exposures of one composition.

There is no such product as the "perfect" film. All films have strengths and weaknesses: What you may gain in one area you can lose in another. Also, be aware that color quality in films can be affected by the quality of processing: Custom processing labs typically produce significantly better results than one-hour photofinishers or dime-store photofinishing outlets. I have always had good results and fast service from Kodak photofinishing for 35mm slide film, but prefer a local custom processor for faster service of 120mm film. Fortunately, publishers generally don't care about the brand of film you use, as long as the images are sharp, well composed, and properly exposed, with good color saturation and high resolution.

For publication quality, color reversal (also known as transparency) film is preferred over prints because transparencies are first-generation positives. With print (or negative) film, the resulting print is second generation. It is easy and inexpensive to have a lab make prints of transparencies.

Regardless of the film brand, it is essential to use as slow a speed (lower ISO number) as possible: Typically, the slower the film, the finer the grain and the sharper the images will be—although this may not always be the case with today's newer films. Unfortunately, the slowest films (ISO 25) are

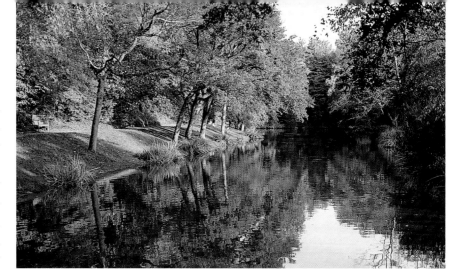

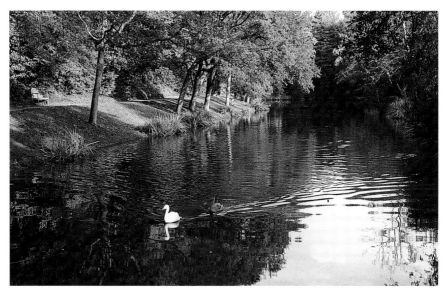

suitable only for studio lighting. For outdoor work, where an overcast day can create low-light conditions, the most practical of the slow films are rated ISO 50, 64, and 100. Film manufacturers constantly improve their offerings' color saturation and grain, so pay special attention to product designation each time you shop, and test new products as they become available. Here are some basic recommendations for garden photography:

• Kodachrome 25 and Kodachrome 64 are classified as "warm" films, superior for "sunset" colors (warm tones such as yellow, red, and orange). They tend to produce "muddy" greens in less-than-ideal lighting conditions. Shade causes even the reds to turn black. Kodachrome 25 is not available in 120-format.

• Ektachrome 64, another Kodak product, is popular for garden photography. It is classified as a "cool" film. It is good for flowers and gardens because it produces bright greens and clean blues, important because green is the color of grass and foliage, while blue is the color of the sky against which most flowers in nature must contrast. Under most conditions, Ektachrome 64 produces pleasing results and natural colors. A drawback is a tendency to take on a blue cast in shade.

Ektachrome 64 is my film of choice because it comes closest to my perception of natural colors. Most of the images in this book were made on this film. I rarely use higher speed Ektachrome films, even though some professionals favor Ektachrome 100S, 100Vs, and 100SW, which Kodak produced in response to a demand for

Canal Garden at the Governor's Palace, Colonial Williamsburg, using Ektachrome (top) and Kodachrome showing how Ektachrome's greens are superior to those of Kodachrome.

Ektachrome 64 Professional film used on a bed of roses in Monet's Garden (left) compared with Fujichrome Velvia (right). Note how the Ektachrome has produced softer tones of green and pink compared with Fujichrome, although both images are professional quality.

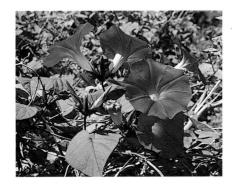

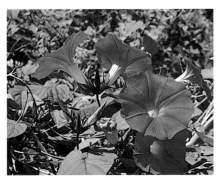

Morning glories under bright light (top) produce a pink cast. A mid-blue filter will correct the petal colors to produce a more realistic blue (bottom).

different degrees of highly saturated film. I prefer to stick with one film speed. Otherwise, I get confused and forget to adjust the ISO setting when using a non-automatic camera.

• Fujichrome Velvia 50 and Fujichrome Provia 100 are "warm" films that tend to enhance the colors of nature. Many professional photographers like these, particularly the newer Provia 100 because of its higher film speed and increased versatility. I find that the greens can suffer in poor light, and the reds can be garish for my sensitivity, but I still shoot a moderate amount of these products.

• Agfachrome RSX2 50 is an excellent professional film for flower and garden photography, with a slightly warm bias. I have used it a lot in Europe, where it is more widely available than in North America. I prefer the greens over Fuji's products, and other colors are more natural.

Try an experiment: Shoot the same scene with Ektachrome 64, Provia 100, and Agfachrome RSX2 50. The quality of Agfachrome might surprise you.

Longevity of Slides

According to film manufacturers, slide film can be stored for 75 to 100 years. Be sure to have film processed as soon as possible after exposure. Here are the best conditions for protecting the images:

• Keep film in the dark; light—especially direct sunlight—fades the dyes.
• Keep it dry; humidity is bad.
• Store slides at 70oF or lower; if summer heat is a problem, protect them in an air-conditioned location. One of the worst places to store unexposed or exposed film—even briefly—is in a car glove compartment. When traveling in hot climates, keep film in a cooler with dry-ice packs. Always store unexposed film in a cool, dry, dark place.

The more often you project a slide, the more likely it will lose its luster, although slides in my file taken 35 years ago are still "publication-quality." Kodachrome 25 and 50 are recommended for longest dark storage, and Ektachrome 64 is recommended for best light resistance, for slides you may project repeatedly for lectures, for example. If planning to project some images repeatedly, consider making duplicates of those slides and projecting the dupes to preserve the originals.

Airport X-ray security inspections can damage film, especially the machines that examine checked baggage. Do not trust the signs that say the equipment "does not damage film." Always carry both exposed and unexposed film through security packed in lead-lined pouches available from camera stores. NEVER pack film in checked baggage because new machines that spot-check luggage to be stowed use much higher doses of radiation than ever before (and you also don't want to take a chance of film and equipment loss). And, because the effect of X-rays is cumulative, if you are traveling through multiple airports and pass through several security checkpoints, this increases the risk. Potential X-ray damage is most critical with ultra-high-speed films, but caution never hurts.

If in doubt, ask for a hand-check of your camera and film—but be aware that this may cause delays, and international airports are not as open to this request as those in the United States.

Film Contrast

Modern color films capture a wide range of tones well, but they cannot adequately record extremes of both dark areas and bright light in the same frame. If the lighting is fairly even, the film can show acceptable overall detail, but in a high-contrast scene such as woodland with dappled light, it's difficult to retain detail in both areas.

In this case, you must decide whether to expose for the dark, shadowy areas or the sunlit areas. In a woodland with a dark floor and a bright overhead tree canopy, for example, I normally would expose for the dark floor and allow the brightly lit canopy to be overexposed.

Color Changes in Natural and Artificial Light

Perhaps the most important lesson to learn when photographing outdoors is that natural daylight can change in the blink of an eye, when a cloud suddenly obscures the sun. With "warm" films, this can turn bright greens dark, and "cool" films will produce a blue cast. Also, significant changes occur throughout the day: Early morning light is "cool"; noon light is "neutral," and late afternoon light is "warm." Color film is balanced for mid-day light. If you seek true colors, natural daylight between 10 a.m. and 3 p.m. in summer is best. However, when shooting a scene for artistic effect, light at other times of the day may be preferred—especially dawn and dusk.

When shooting indoors under artificial light, you must determine whether the artificial source is incandescent, daylight, or fluorescent bulbs, and choose the appropriate film (see *Chapter 9*).

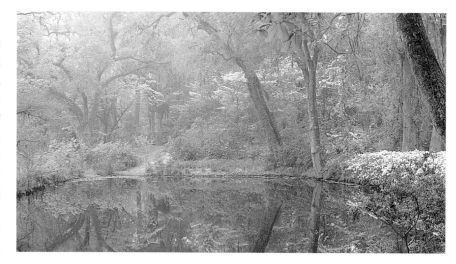

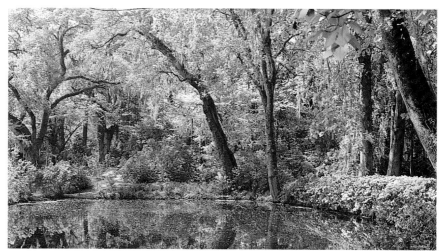

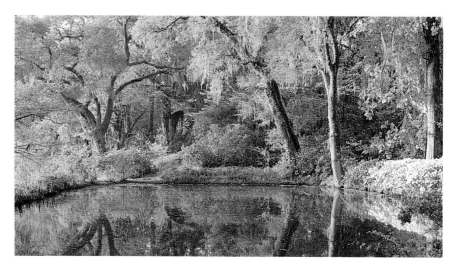

Three images of the same landscape at Magnolia Plantation, South Carolina, at different times of the day, using Ektachrome 64 Professional film. *Connoisseur* magazine chose the bottom exposure for a double-page spread to illustrate an article about the garden by Henry Mitchell.

Kodachrome has a reputation for producing the best reds, but only in bright light. In the image below, also on Kodachrome, see how the reds become "muddy" when a cloud suddenly obscures the sun. Because green generally is the most important color in garden photography, when evaluating films, compare the greens produced by different films in both sunlight and shade.

Light Meters

In the past, photographers used separate handheld light meters to check correct exposure. There are two kinds: One you point toward the subject to measure reflected light; the other is aimed toward the camera to measure incident light directed at the subject. Today, most quality cameras have built-in meters that accurately measure light through the lens (TTL) and read the amount of light actually reaching the film (OTF—off the film). This makes separate light meters unnecessary.

Even with TTL and OTF metering, though, there are times when compensation may be required for a good exposure. For example, if the subject is surrounded by an extremely bright sky, a TTL or OTF system that is measuring the full frame may produce a dark image. In such a case, using the camera's spot metering mode will direct the camera to measure the light on the smaller area rather than the surrounding sky.

Even so, a TTL or OTF metering system can still be fooled by "glare," such as a brightly lit beach or a snow scene, which may result in underexposure. In this case, compensate manually by overexposing as much as 2 stops. Or, you may have a dark object surrounded by white. Correct this by overexposing 1 stop for dark objects surrounded by glare; or if your camera offers this feature, press the "compensation" button, which tells the camera to make the correction automatically. Rather than trust the camera to make the compensation, though, it is often preferred to "bracket" a series of three exposures: for example, shooting a snow scene at 1 stop over the camera's reading, then 1-1/2 stops over, and finally 2 stops over.

Lenses

There is no universal lens that functions like the human eye, changing focus from extreme close-up to infinity, and recording a concentrated area or a large area in the flicker of an eyelid. Most medium-format cameras have a standard lens that focuses from infinity to between two and three feet in clear detail. In 35mm, that distance is about 1-1/2 feet.

• **Close-up:** Use special micro close-up and macro close-up lenses to get even closer. Another alternative is one of the most useful tools in plant photography: a simple close-up extension tube that mounts between the camera and lens and allows the standard lens to focus closer.

Other options include close-up diopters that come in sets with designations like #1, #2, and #3 that take you progressively closer to the subject. They look like clear filters and mount to the standard lens; I use the #3 diopter the most. If you want to "stack" more than one to further increase magnification, be sure the higher number is mounted closer to the lens. Bellows attachments can also be used for photographing objects at extreme magnification.

Professional photographers use different accessories depending on the situation. You may find it best to master one and stick with it. More about close-up techniques in *Chapter 8*.

When taking close-ups, there is little depth of field—area of sharp focus; the wider the lens aperture, the shorter this becomes. Generally, it is best to open the lens no wider than f/11 for close-ups of plants, although some interesting visual effects can result from stopping down drastically so only a tiny area is in focus. The British magazine, *Gardens Illustrated*, regularly uses this kind of image on its covers.

• **Telephoto:** Many garden magazines reject images that show distortion, a problem especially with telephoto lenses, which distort distances between plants. Plants in the landscape may appear much closer together than they actually are. However, some publications like telephoto images because they prefer the dramatic telescoping effect.

These types of images have their place, providing the captions explain this to the reader. Although there are some very powerful telephoto lenses for 35mm cameras (mostly used by bird photographers), I have found that 135mm creates the least apparent distortion when photographing garden details from a distance. (See *Chapter 7*, "Grand Landscapes & Scenic Views").

Perhaps the most important lesson to learn when photographing outdoors is that natural daylight can change in the blink of an eye...

- **Wide-angle:** Here, too, many potential buyers will reject wide-angle shots because they can distort the image. However, a 28mm wide-angle lens can be extremely useful to show the design of a large area that is beyond the scope of a standard lens. There is a big demand for overall views of gardens, and often the only way to include the boundaries is to use a wide-angle lens. To avoid distortion, shoot from a high elevation.

Accessories

Although I have stated that simplicity is the key to good plant photography, you may find other accessories useful.

- **Tripod:** I would estimate that 95% of my work is shot using a camera mounted on a sturdy tripod. When working at any shutter speed slower than 1/60-second, a tripod is essential for sharp images. Some public gardens ban tripods unless a tripod permit is granted, but allow monopods, which are one-legged tripods. Beware of inexpensive models; generally, lightweight ones are flimsy and easily damaged—the sturdier the better.
- **Cable release:** A cable release allows you to trip the shutter and make an exposure without touching the camera or tripod, thereby avoiding any movement that might blur the image—especially during time exposures.
- **Filters:** Dozens of filters are available from well-known manufacturers such as Tiffen®. I do not use filters often, however you may want to consider a haze filter, skylight filter, mid-blue filter, soft-focus attachment, and a polarizer.

Haze (or ultraviolet—UV) Filter: Atmospheric haze can obscure the view when shooting landscapes and scenics. Most often this is seen on film as a blue "mist." The problem is encountered frequently along the ocean, in mountains, and in tropical climates. UV radiation affects film and gives the appearance of haze; the problem gets worse at increasing altitudes. This filter cuts through the haze and allows the film to record a clear view.

Skylight Filter: When shooting in shade, natural light is too blue. Thus, light-colored subjects such as white flowers photograph with a blue cast. A skylight filter records truer colors in shade and also helps screen out UV radiation.

Mid-blue Filter: I'll talk more about this accessory in *Chapter 2*, "Problem Flowers and 'Anomalous Reflectance'," when I explain the ageratum effect, related to photographing some blue flowers.

Polarizer: This eliminates reflected glare and improves scenic views with water as the predominant feature. It removes surface glare so film can record deep into the water. A polarizing filter also improves dark green foliage when the film would otherwise record a tropical garden's lush greenery as dismal, dark green tones. Polarizers are also good for darkening a blue sky, giving images a "picture postcard" look.

Soft-focus Attachment: You will see many images on greeting cards of flowers and gardens with a soft, diffused, misty effect, producing a romantic quality. Sometimes the image shows only partial diffusion, with the misty appearance only around the edges. These effects are created with different types of soft-focus attachments. A similar effect can be achieved by smearing the edges of a haze or clear-glass filter with petroleum jelly, or—for full diffusion—by breathing heavily on the lens surface and shooting before the condensation disappears.

- **Portable Backgrounds:** When a plant is in an undesirable setting, or you want a completely uniform background for a series of pictures, an artificial background may be called for. You can make these backgrounds easily from 2-1/2-foot-square pieces of lightweight particle board, painted with a matte finish. Basic backgrounds to consider include:

Sky: Light blue is preferred, streaked with white to simulate clouds. Sky is the most natural of backgrounds for flowers.

Green: Dappled green is preferred, using a bright green paint streaked with white to simulate a foliage background. As with sky, green foliage is a natural background for flowers.

Black: Use for dramatic close-ups and to simulate night when photographing night-blooming plants, such as a cereus and moonflowers, during daylight hours.

Rustic Fence: Create a portable "stockade" or picket fence to screen out extraneous backgrounds when photographing a section of border.

Other Useful Aids: Here are some additional helpful accessories:

Wind Break: A sheet of clear plastic acrylic to shelter flowers from wind. To stop flower movement without a wind break, use a

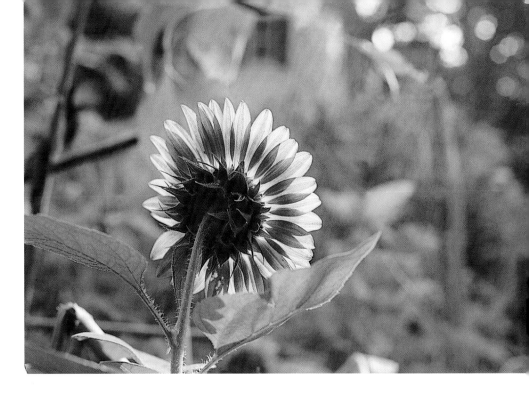

shutter speed of 1/60-second or faster, although some apparent movement of flowers (like poppies in a meadow) is sometimes desirable.

Reflector: A sheet of stiff white cardboard, a mirror, or a sheet of aluminum foil wrapped around a board can be used to bounce light into heavily shaded areas. Even better is a commercially available circular folding reflector that fits handily into a camera bag but opens out to a 2-1/2-foot (and larger) diameter circle, with a white surface on one side and a shiny surface on the other.

Diffuser: Just as you need a reflector to bounce light into dark, shadowy areas, you will sometimes need a diffuser to reduce glaring sunlight. This is particularly true for close-ups. Camera stores sell a variety of diffusers in the form of umbrellas made from a transparent white cloth, and white canopies.

Atomizer: A fine, misty spray of water on some fruits, vegetables, leaves, and flower petals not only helps produce a more dramatic color, but the mist can also form droplets of dew to enliven a "posed" picture.

Pocket Knife: I carry a sharp pocket knife, not only to slice open fruit, but to cut stems, to remove obstructions, and arrange flowers.

Notebook & Pen: On my photographic forays, I wear a photographer's vest with lots of "cargo pockets" to carry my useful accessories. The breast pocket is always reserved for a notebook and pen for recording plant names. Don't depend on your memory to remember plant names; you should record both the botanical and common name for proper identification.

Toothpicks: These are helpful to position fruit and vegetables in arrangements, and for repairing flower clusters where several flowers may be blemished. Groups of crocus, for example, can be tidied-up by replacing faded blooms with fresh ones stuck into the soil on toothpicks.

Artificial Lights: Flash and other means of artificial lighting are covered in *Chapter 9*.

Backlit petals of a sunflower cause the flower head to glow like a Chinese lantern. The impressionist painter, Monet, preferred to plant flowers with a single row of petals like this because of the shimmering quality they gave to his garden.

Many people may feel that flower photography is plant photography. That's not so, of course, because trees, shrubs, vegetables, foliage plants, and other forms of plant life can also be stimulating subjects. Because most plants—even foliage plants—have flowers at some stage of their life cycle, flowers are likely to command most of your attention. They are the most photogenic and colorful subjects in the fascinating world of plants, and they account for the greatest sales to publishers.

In my view, the test of a really good flower photographer is the ability to photograph the subjects as they grow in nature. Their natural beauty and surroundings are usually so breathtaking, it irritates me to see the efforts of some photographers to pose them awkwardly against artificial backgrounds or flood their interesting forms and delicate textures with artificial light. Often, catalog pictures are the worst offenders, showing graceful flowers stiffly arranged against alien backgrounds.

There is no substitute for natural light and outdoor backgrounds when photographing flowers. The greatest animal and bird pictures are not taken

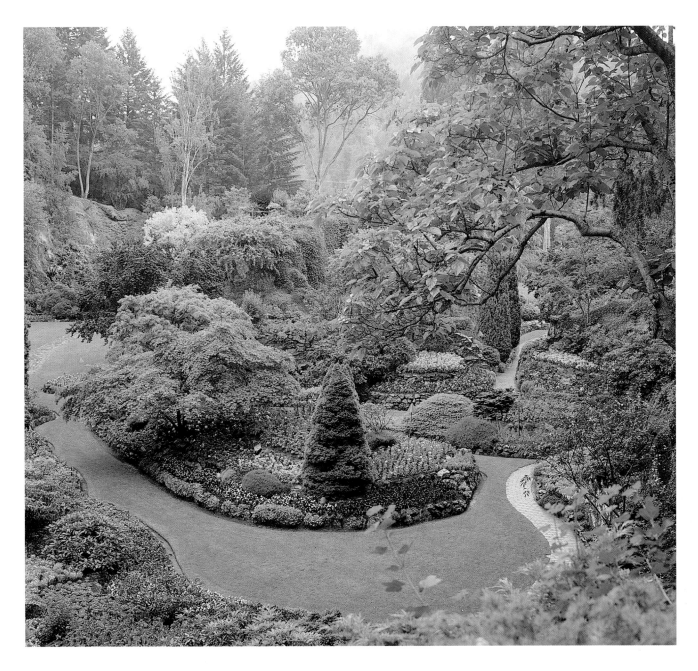

in zoos, or with the animal tethered against a fake background. The same holds true for flowers and there is less excuse for falsity because your subject will pose for hours, whereas bird and animal photographers must sit for endless periods in concealment for one split-second opportunity.

Where to Begin

One of the delights of flower photography is that your subjects are easily accessible. A worthwhile investment for a flower photographer is to join a state or national horticultural society. Consult your local library, county agricultural agent, or a local botanical garden for information about these groups. For a modest membership fee, you will receive bulletins giving valuable information about tours to many locations where flowers are grown in ideal surroundings.

Butchart Gardens, near Victoria, on Vancouver Island, is so intensively planted, with strong contrasts of green lawns, paths, and flowers, it provides opportunities for dramatic overall views ideal for posters, calendars, and book covers.

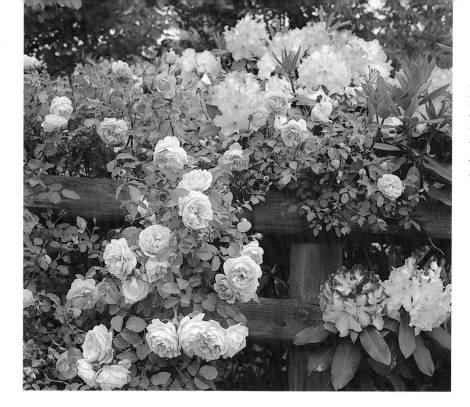

Always be alert for "companion plantings" where two or more flowers complement each other. Here, the English Heritage rose, "Graham Thomas" makes a perfect partner with a late-flowering rhododendron, "Walloper."

Don't overlook local parks and arboretums, or garden centers, nurseries, and commercial growers. I lived in my present home for ten years before I discovered that one of North America's biggest bedding plant growers was located three miles away, with nine acres of greenhouses filled with flowers during every season. This resource has proved even better for close-up work than public and private gardens, because the flowers are grown under the protection of glass, and remain blemish-free for long periods.

When shooting in public and private gardens, respect the work gardeners have put into preparing the ground and border plantings. Tread warily, obey regulations and ask permission when you wish to enter normally out-of-bounds areas. Do not litter the grounds with empty film cartons or other refuse, and if you wish to take a plant home, offer to pay for it.

The excitement of finding a perfect specimen in peak condition, in a stimulating setting, with the light falling just right, and with the background showing off the bloom to absolute perfection, is similar to the thrill a bird photographer feels when, after waiting all day, the eagle finally returns to her nest and strikes a majestic pose that could never be imitated in captivity. Patience rewards the plant photographer who meticulously searches through an acre of

The sun can produce heavy shadows among flower petals. A reflector can bounce light into the shadowy areas to create a better picture.

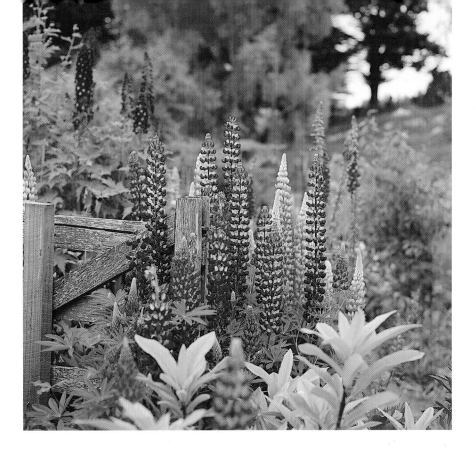

roses, seeking the one rose that outshines all the rest, ruthlessly ignoring hundreds of possible mediocre pictures—or who discovers a healthy clump of perennials past their prime and makes a mental note to return to the same spot a little earlier the following year.

Flower Shows

In my experience, flower shows generally are poor locations for photography. On film, most of the displays look "staged" and even if you can gain admission on a "press day" when people are not milling about, the light can be poor and backgrounds unattractive—especially in tents where the canvas can cause an unsettling yellow cast. When I visit a flower show, I generally leave my camera at home, and tour the exhibits with a pen and pencil, noting the best exhibitors and their addresses for after-the-show photography at their business locations. That way, I have found superb orchid, cacti, and African violet growers among the commercial displays, and discovered sensational rock gardens and rhododendron gardens among educational displays staged by the North American Rock Garden Society and the North American Rhododendron Society.

Photogenic Garden Flowers

Some groups of garden flowers are distinctly more photogenic than others and are repeatedly requested by photo editors. Some are so appealing, such as orchids, cacti, and roses, that it is possible to earn a modest income concentrating on a particular plant family. Here is my Top 20 list of favorite photogenic flowers, based not only on visual appeal but also on demand from photo editors.

There is a bigger demand for flowers showing a mixture of colors rather than a single color. Because these lupines present a rich array of colors, they have been used for calendar and seed-packet illustration. Note how the rustic wooden gate adds an appealing textural contrast to delicate flower spikes.

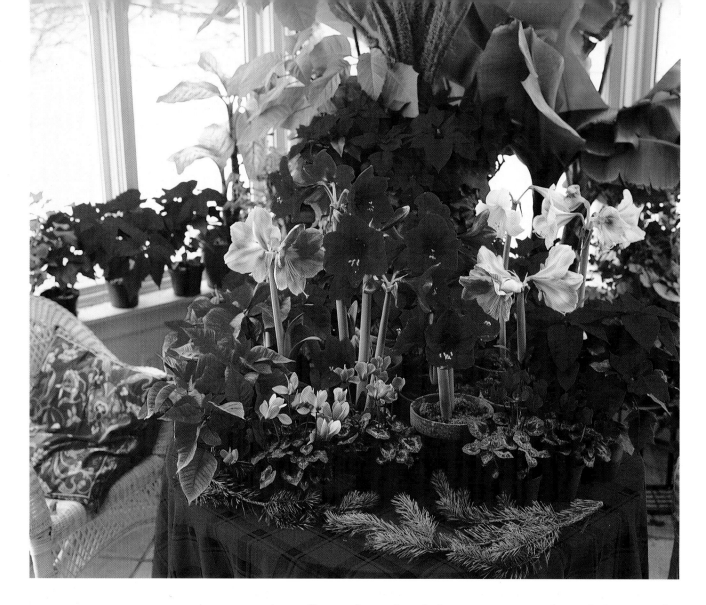

When plants such as amaryllis are photographed under glass, in greenhouses and conservatories, the glass helps to diffuse the light, resulting in strong colors.

Amaryllis: I almost listed the poinsettia in place of the amaryllis because the color range of poinsettias has expanded dramatically in recent years and photo editors are always seeking good images to tie in with Christmas. However, the amaryllis is also a symbol of Christmas. It has a much wider color range and in mild winter areas it can be grown more easily as a garden flower than the poinsettia.

In addition to the common red amaryllis, there are white, pink, orange, and bicolored varieties. In the mountains north of Rio de Janeiro, Brazil, during the month of March, I even encountered a rare blue variety, and wondered why an enterprising nurseryman has not propagated them for sale. Amaryllis have spectacularly large flowers—up to ten inches across—and as many as six flowers can be clustered atop a tall stem all at one time. This cluster can be so heavy that the plant may need staking, although generally it is best to hide the stake so it doesn't show in pictures. Also, amaryllis have prominent powdery yellow stamens that project forward a long way; if you shoot head-on with the flower throat in focus, the stamens can be blurred. Shooting at a slight angle often allows you to keep the stamens and the throat of the flower sharply focused.

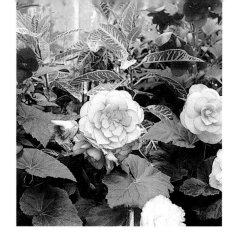

Tuberous begonias have exotic blooms and beautiful, large, velvety leaves. Grown outdoors, the petals and leaves are prone to blemishes from pests and sunburn, but under glass they can be picture-perfect.

Begonias: This is an enormous family of plants that includes the large-flowered tuberous begonias with flowers up to eight inches across, free-flowering bedding begonias, and decorative fancy-leaf Rex begonias. The spectacular tuberous begonias are often grown in pots, and some have a cascading habit for growing in hanging baskets. They flower continuously all summer in lightly shaded locations, and are favorites for growing under glass in pots.

The central flower of a tuberous begonia usually is the largest and a male; the side flowers are females, growing slightly smaller. To get the biggest blooms, growers for exhibition will snip off the females so all the plant's energy is concentrated into growing one massive main flower, offering the best subject for close-up photography. In the garden, unfortunately, petals and leaves quickly blemish from rain spots and drought, so the best locations are conservatory displays and greenhouse growers who specialize in growing begonias.

Cactus: Most people think of cacti as boring, undemanding, spiny plants that squat in a pot of dry soil and grow so slowly they hardly seem alive. The truth is that many are so elegant in form that they are valued for their sculptural qualities, while others produce spectacular blooms that can outshine even orchids in brilliance. Cacti are native to the desert areas of North America, and consist of two types: desert cacti that enjoy full sun, such as saguaros (the state flower of Arizona), and jungle cacti, such as the Christmas cactus, that live in the crotches of trees and prefer a lightly shaded location. Some of the jungle cacti produce immense blooms, up to ten inches across, in shimmering colors that include red, orange, and yellow.

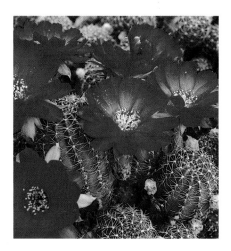

Cacti have been hybridized to create many exotic colors. This lobivia hybrid, appropriately named "Red Riding Hood," has exquisite flowers. With cacti, it is important to show the shape of the plant, especially the spines if they are present.

It's fun to photograph collections of cacti in greenhouses. Most of the desert species bloom indoors in May and June, while the jungle cacti bloom mainly during summer months. Specialist greenhouse growers and hobbyists often have hundreds of species and hybrids, but it's even better to photograph them in their natural habitat, such as the Sonoran Desert or the Amazon rain forest. Surprisingly, species of prickly pear cacti grow wild in North America as far north as the Canadian border, mostly among sand dunes and rock ledges. But in the wild, it is the tall, statuesque saguaros that command attention, especially silhouetted against a desert sunset or with their crown of white flowers being pollinated by hummingbirds, bats, or bees.

Over the years, I have produced such an extensive file of cacti photographs that I was able to produce a children's book, *Cacti*, for The Creative Company's *Let's Investigate Plants* series, illustrated with more than 100 images and a text of 2500 words.

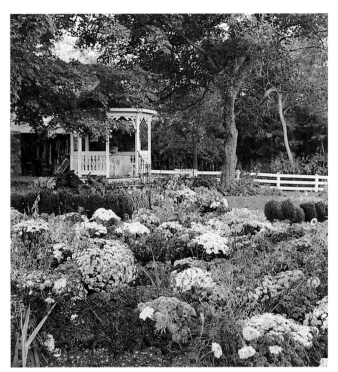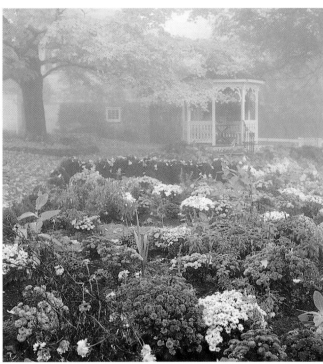

When an editor is presented with two similar images, the one that shows a strong sense of season and a special lighting quality will generally win favor. Invariably, of these two chrysanthemum gardens, the one showing a misty morning is chosen for publication.

Chrysanthemums: Although most people are familiar with the "cushion" mum sold by garden centers for autumn floral displays at Thanksgiving, this is a diverse plant family that also includes the large globular "football" mums, "spider" mums with sharp, quilled petals, and "spoon" mums with petals flattened at the tip and narrowed at the base, presenting a starburst effect.

Cushion mums have been cultivated by the Chinese and Japanese for centuries, and the color range is extensive. They are mound-shaped plants with so many flowers that often the foliage is completely hidden from view. They are most effective photographed in massed beds or long, colorful borders with autumn leaves in the background.

Clematis: Of all hardy flowering vines, clematis are the most showy, the most diverse in their color range, and the largest flowered, with some flowers measuring eight inches across. Although white, blue, and red are the primary colors, they have been hybridized to produce spectacular bicolors. They are beautiful in close-ups, but editors prefer to see an interesting support in the background, especially a trellis or ornate metalwork. Also in big demand are two or three varieties entwining their colors, and clematis varieties in company with other popular vining plants such as honeysuckle and roses. Clematis are also beautiful photographed against old brick walls, trailing along split-rail fences and over stone structures.

Clematis not only look good by themselves, but often they can be found entwining their flowers among those of a flowering shrub or tree. Here, clematis "Nelly Moser" is partnered with an Exbury azalea for an appealing combination.

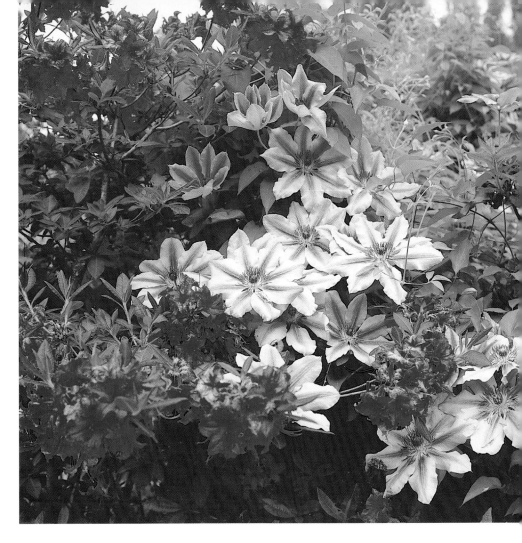

Clematis have a romantic aura about them, and although most varieties bloom in spring, some extend the flowering season into summer and even autumn months. Unfortunately, both the light-blue and deep-blue varieties are prone to the "ageratum effect" (see "Problem Flowers and 'Anomalous Reflectance'" later in this chapter), showing a tendency to photograph pink rather than blue unless color is corrected with a filter.

Daffodils: Daffodils gave me my first big break as a professional photographer! I used to live next to fashion stylist Robert Greene, who had a magnificent garden—particularly in spring when hundreds of thousands of daffodils bloomed across meadows and along streams. Robert was there only on weekends and allowed me free access to the property at any time. One day he called to say that an *Architectural Digest* freelance photographer from New York had been out to shoot the garden, but the results were disappointing and the magazine was not going to run the feature. He asked if he could borrow my photography to give them a better choice.

Months later I was amazed to receive a sample copy of the magazine with my pictures illustrating Robert Greene's garden (November 1977), followed by a call from the art director who not only negotiated a generous payment but expressed interest in seeing more of my garden photography. Since then, I have contributed more than 50 garden and travel features to *Architectural Digest*, which still maintains the highest quality among "shelter" magazines.

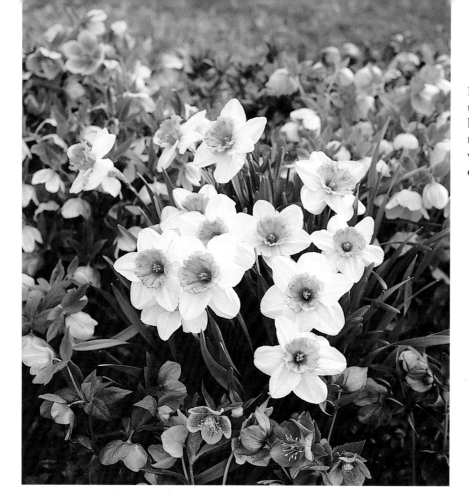

Most daffodils photograph best under diffused light. In bright sunlight, the whites of daffodil petals tend to become overexposed. This variety is "Duke of Windsor" in company with helleborus.

What I like most about daffodils is that they are the earliest showy flower to bloom in the spring, even ahead of the great tulip displays. To be sure, there are many other flowers that bloom earlier, such as snowdrops and winter aconites, but they don't make such a big impact in the landscape. Indeed, a garden's reputation can be made with daffodils, especially when they are planted thickly to create drifts across sunny meadows and shadowy woodlands.

You may think that daffodils don't offer much variation in color because they are predominantly white or yellow, but when you get in close for macro photography, the trumpet (the inner circle of petals) can show a more extensive color range, including green, orange, red, and pink. Sometimes the trumpet extends so far forward, it's difficult to know where to focus in extreme close-ups: My preference is for the cluster of powdery yellow stamens that usually extend midway along the trumpet.

Naturalized plantings of daffodils make exquisite scenic pictures, especially surrounding an early flowering tree such as a saucer magnolia or a weeping cherry. Classic settings are a sunny bank bordering a stream or pond, as a ribbon of color along a woodland path, as a sea of color under flowering orchard trees, such as peaches and plums. Also consider photographing daffodils with anything blue for contrast; yellow and blue make good color contrasts. The blue can be a blue sky, blue water reflections or blue flowers like grape hyacinths and forget-me-nots. Also, daffodils can be used to create a "yellow" theme garden, partnered with yellow pansies, yellow celandine, and yellow forsythia.

...consider photographing daffodils with anything blue for contrast; yellow and blue make good color contrasts...

The quilled petals of this tuberous dahlia, "Pink Princess," make it an appealing close-up—more so when a group of blemish-free blossoms can be included in the composition.

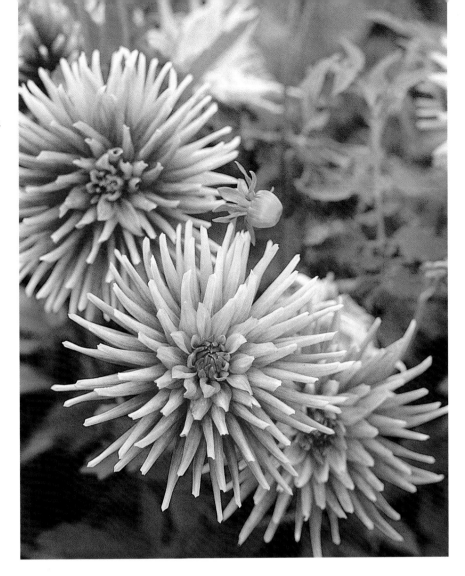

Dahlias: Dahlias bloom all summer but, because they seem to peak just before fall frosts, they are strongly associated with autumn. The large dinner-plate dahlias, with smooth round or quilled petals, are the most popular among publishers. These grow to ten inches across in a vast assortment of colors, including exotic bicolors. The Pacific Northwest and New Zealand are the main production areas, where it's possible to see vast fields stretching to the horizon. They are grown mostly from tubers, flowering from midsummer to fall frost.

Generally, the best pictures are those that show a single blemish-free bloom and a bud, or a tight cluster of several blooms. Also, dahlias make some of the most spectacular arrangements, especially in a window where fall foliage can be seen in the background.

Daylilies: Although daylilies grow wild along the waysides of most states, they are native to China, and a number of Asian species have been used to hybridize a vast selection of varieties. Several specialist breeders have made some spectacular color breakthroughs, particularly in producing bicolored varieties with a maroon or red throat. The Siloam strain of daylilies is noted for its sensational color combinations. The growing of daylilies is a popular cottage industry, so there is hardly an area of the country where specialist growers cannot be found.

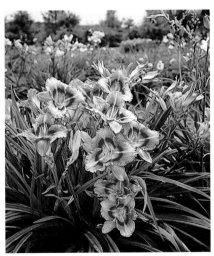

Daylilies present an extremely rich array of colors. The "Siloam" hybrids in particular are noted for unusual bi-coloration, including a dark zone around the throat of the flower.

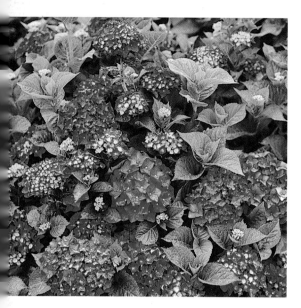

When grown in neutral soil, hydrangeas can present flowers of different hues, from red to blue, sometimes with sensational results.

Close-ups showing a single flower with a cluster of unopened buds can look dramatic, and there is a steady demand for scenes showing daylilies used prominently in mixed perennial borders. Also, several compact dwarf varieties, such as orange Stella d'Oro and yellow Happy Returns are suitable for growing in containers. The season for daylilies extends from June through September, with August the peak month.

Hydrangeas: These shrubby plants flower mostly during summer months. They have strong associations with the Victorian era and Southern plantation gardens. The two main groups are known as florist (with globular blooms in mostly red, pink, purple, blue, and white) and lace-caps (displaying flat, airy flowers in a similar color range).

An interesting fact about hydrangeas is that soil chemistry can change the colors so several hues may be present on the same plant. Acidic soils generally produce blue blooms, and alkaline soils pink. They tolerate light shade, so I enjoy photographing them in mysterious woodland settings, or in rugged coastal locations in association with other flowering plants like roses and honeysuckle.

Irises: All kinds of irises are sought by photo editors: the yellow flag iris (*I. pseodacorus*) in association with water features; the blue Siberians (*I. siberica*) in combination with peonies; the Dutch iris (*I. x hollandica*) in white, blue, apricot, and yellow, coupled with late-flowering tulips; and the Japanese iris (*I. ensata*), which is rich in white, blue, and purple, and looks sensational bordering a stream. However, the biggest demand by far is for examples of bearded irises (*I x germanica*) used in garden situations with other big perennials such as peonies and Oriental poppies. Bearded irises also make dramatic close-ups because their color range is the most extensive in all the plant kingdom, with the exception of orchids. In particular demand are bearded iris varieties that have won awards from the American Iris Society.

Although Oregon and Washington State, with hundreds of acres devoted to propagation, are the main production areas, there are large iris collections in almost every US botanical garden. Two of the best collections of bearded irises are in Monet's Garden, France, the first week of June, and at the Presby Memorial Iris Garden, Montclair, New Jersey, during the same period. In Monet's Garden, irises are grown in company with roses and other beautiful perennials, while the Presby Memorial Iris Garden features long, sweeping beds of modern and heirloom varieties, arranged according to the year of their introduction, and presenting a succession of "rainbow" borders. The floral display seems to last for several weeks, but there is usually one particular day when the irises are at their peak.

Because the blossom is quite intricate and easily spoiled by heavy rains, the big challenge is to not only hit that flowering peak for the most dramatic pictures, but to find blossoms for close-ups that are symmetrical and unblemished. Each bearded iris flower has a set of three upward arching petals called *standards*, and a downward facing set called falls. Shoot a single iris close-up head-on to one of the falls in such a way that the other two

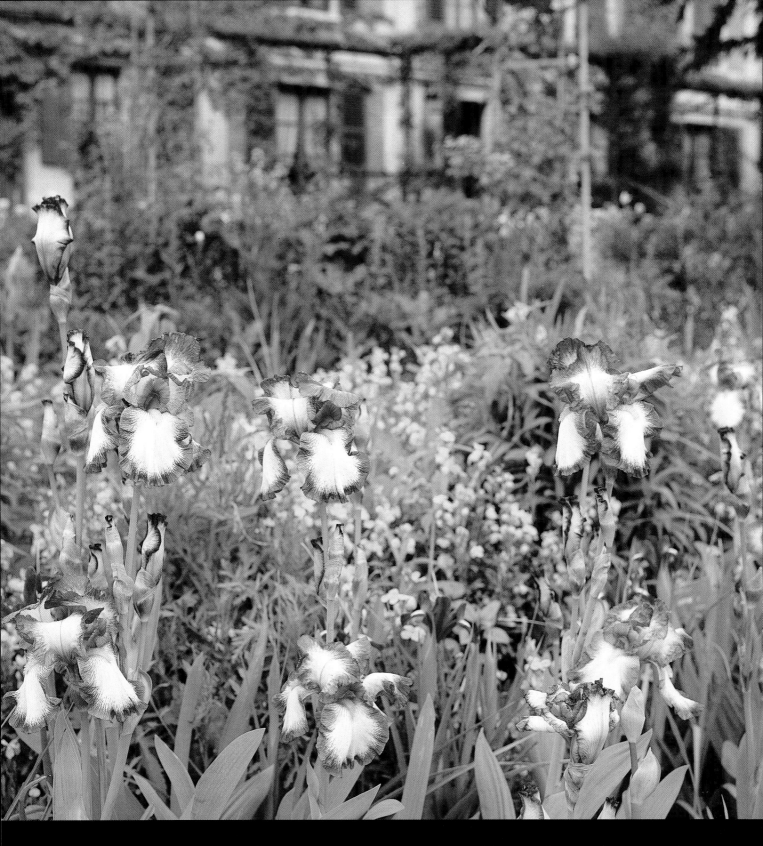

The pairing of blue irises and yellow wallflowers in Monet's Garden reveals one of the artist's favorite color harmonies.

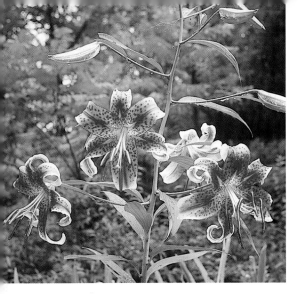

Lily "Imperial Crimson" showing a magnificent flower spike with fully open flowers and buds. Although close-ups of a single flower are spectacular, never overlook the impact of a full flower spray like this, and try to show a sense of place. Lilies love shade, so the sense of a woodland setting, rather than clear blue sky, is appropriate.

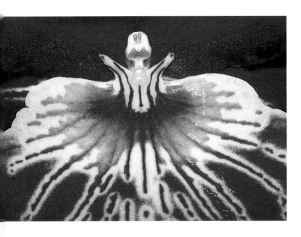

Close-up of a miltonia orchid, "Beethoven," shows how the center of the flower resembles a female moth in flight, intended to attract male moths for pollination.

falls are shown in profile—like wings—and the standards sweep upward in a perfect arch. Focus should always be at the top of the "beard," which is usually yellow or orange.

Avoid shooting irises in harsh sunlight because the colors change and can become washed out.

Lilies: The true family of lilies (known botanically as *Lilium*) is confusing. Among the many impostors are plantain lilies, spider lilies, and daylilies. *Lilium* species and hybrids, commonly called garden lilies or florist lilies, are extremely colorful and among the most beautiful flowers for close-ups. Every year, hundreds of photos are used on greeting cards, especially at Easter, for bereavement and for Mother's Day.

It pays to have a little knowledge of lily classification because there are several major groups, some of which are in greater demand than others. For example, there are lily species (wild lilies) and hybrids produced from crossing the species. Two popular species grown in gardens are the tiger lily (*Lilium lancifolium*), native to Japan, and the Canada lily (*Lilium canadensis*), native to North America. However, those most often seen in home gardens are the Asiatic hybrids, most of which have upward-facing blooms in a rich color range that includes red, yellow, orange, purple, pink, white, and bicolors.

Another popular group is the Oriental hybrid. These have huge blooms up to ten inches across, in mostly red, pink, white, and yellow. Trumpet lilies (generally hybrids of *Lilium longiflorum*) are another popular garden flower, and also crosses between the trumpet lilies and Asiatics, known as LA Hybrids (or Super Asiatics). Some of these have trumpet-shaped blooms, and others chalice-shaped blooms, but all are large-flowered with exotic colors not found in other lily groups. An image often requested by photo editors is of a complete lily garden, with several different kinds planted in a colorful bed or border. Also, clumps of individual varieties photographed beside a pond or stream, in woodland, against a rustic fence and among ferns, make lovely garden scenes.

A striking lily close-up is the prominent arrangement of anthers at the center of each flower. Usually a dusty brown color, they can stain clothing; florists often remove these before selling the lilies as cut flowers. For photography, however, you need the anthers in place because they add to the flower's "drama," and you generally need to focus on the anthers to get a pleasing picture.

Orchids: Considered to be the most complex of all flowering plants, the fascinating flower patterns and near-human characteristics of orchids make them a flower photographer's delight. More than 35,000 species and hybrid varieties are thought to exist, and distinct new forms are being created every year. Once you get in close to an orchid, it is easy to understand why they are held in such high esteem, and why the American Orchid Society is the largest plant society in the world.

Single and group close-ups are simply sensational. Good backgrounds are feathery ferns, tropical foliage, and shadowy darkness. Artificial backgrounds of dappled blue, dappled green, and black are acceptable substitutes.

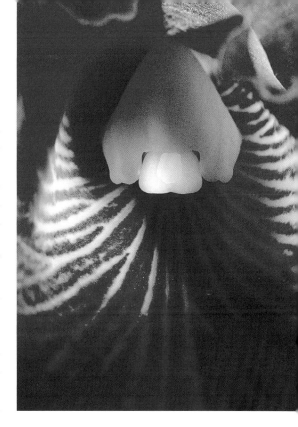

Focus is a problem when shooting many orchids. Members of the popular *Cattleya* species (the florist orchid) have graceful petals that arch back, and a frilly lip that can project far forward. Depth of field can be insufficient to keep the whole flower in sharp focus. To gain as much depth of field as possible, use as small an aperture as possible—even f/16 or f/22.

Then decide what is the flower's most distinctive feature. It could be a pattern of spots on the inside of the lip used to attract insect pollinators. In pansy orchids (*Miltonias*), you will see at the center of the flower a pattern that resembles a moth in flight! The orchid uses the illusion to attract male moths that try to mate with the flower. In the process, it picks up pollen for transfer to another orchid. Look at a hundred *Miltonias* and you will see the same impression of a fluttering moth, yet no two patterns are identical. It is one of nature's most miraculous imitations, and for the flower photographer with a close-up lens, it can be a source of endless hours of fun.

Amazingly, orchids are descended from iris, but in orchids the male and female parts of the flower are fused together to form a nose—or a column—that can be a distinctive feature and a good place to focus for dramatic close-ups.

The best time to visit orchid nurseries is just before Easter, when most commercial growers have a wide assortment in full bloom. Although orchids in the wild are mostly indigenous to the tropics, particularly Costa Rica, North America has some beautiful, hardy species, including the yellow and pink ladyslipper orchids that grow mostly in woodlands, and flower in late spring. Unfortunately, over-browsing by deer has drastically depleted native colonies of ladyslipper orchids in the wild, but it is still possible to find photogenic healthy clumps in wildflower preserves.

There are many amateur orchid growers who love to have their prize specimens immortalized on film. Locate the local chapter of the American Orchid Society and contact orchid fanciers by attending their meetings. Soon you may be an orchid addict yourself, which may leave you precious little time for photography!

Peonies: There are two main types of peonies: the old-fashioned herbaceous peonies that bloom mainly in late spring, and the more spectacular tree peonies that bloom a little earlier.

Most herbaceous peonies are white, pink, or red, in single and double forms. The singles and semi-doubles have a golden dome of stamens at the center, which is a good place to focus when shooting close-ups. They are long-lived as hardy perennials and will form dense, bushy hedges, although the plants die down and go dormant after frost. They are best photographed in company with other hardy perennials such as bearded irises, foxgloves, Oriental poppies, and roses because close-ups of tree peony blooms are far more alluring.

Tree peonies can grow huge flowers up to 12 inches across, with petals that look like they are made of silk. One perfect tree peony can outshine an entire border of herbaceous peonies, and the color range is more extensive—not only displaying white, pink, and red, but purple, maroon, orange, apricot, and yellow. They also display a conspicuous crown of powdery yellow stamens that must be in sharp focus for good close-ups.

Hybrids of cattleya orchids have especially colorful throats. Using a simple close-up extension tube allows an intimate view of the orchid's sexual parts.

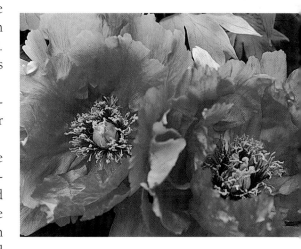

Peonies are classified as "tree" types and "herbaceous." Tree peonies have the largest and most photogenic flowers, especially in tight close-ups.

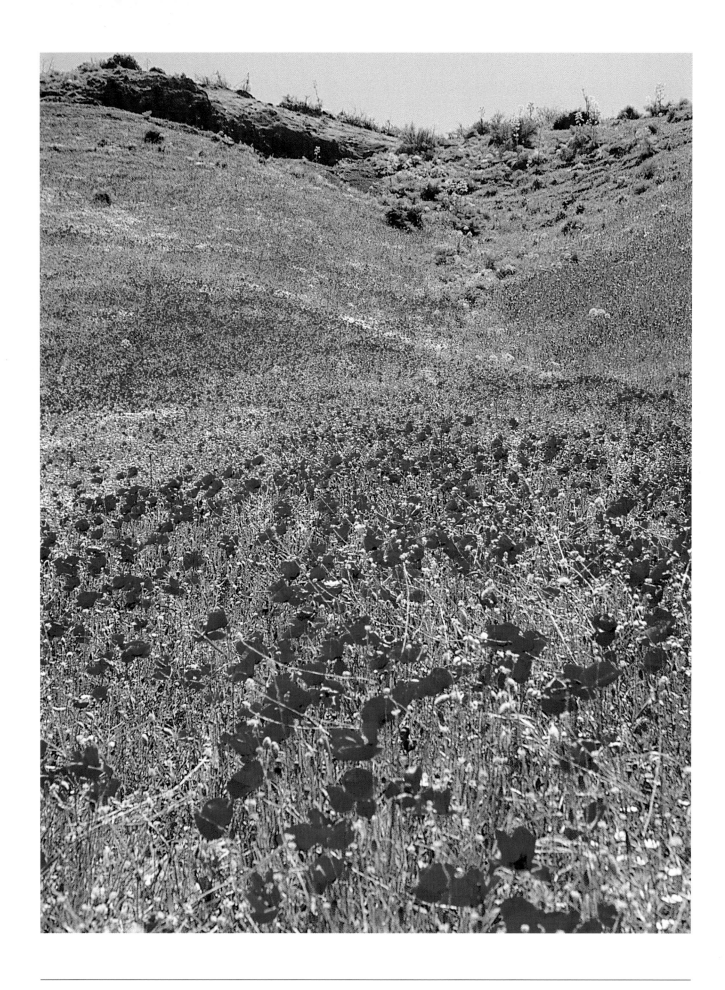

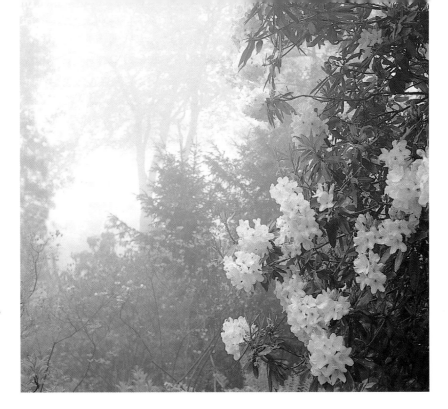

(Opposite page) An avalanche of red annual corn poppies cascades down a mountain slope beside the main highway from Fez to Marrakech in Morocco.

Rhododendrons are never more beautiful than when photographed in the cool light of a misty morning, here captured at Princess Sturdza's woodland garden on the Normandy coast. I was able to spend the night in her guest cottage so I could be in the garden at daybreak.

Poppies: The most-often requested poppy pictures are the Oriental, the Iceland, the Himalayan blue, and European Shirley poppies (also known as corn or Flanders field poppies). Orientals are the largest flowered, displaying blooms up to ten inches across, and they are the hardiest, coming back as perennials even after severe winters. Colors are mostly red, pink, and white. Iceland poppies are biennials, mostly grown as annuals to bloom for one season. They include yellow and bright orange in their color range and, although they are smaller-flowered, they tend to outshine the Orientals.

The European Shirley poppy is a fast-growing annual named for an English parson who developed them from wild corn poppies. Its color range is similar to the Oriental, and it looks best in meadow plantings where its warm colors can contrast with cooler colors like blue cornflowers.

A prolific seeder, the poppy quickly colonizes fallow fields, especially in Provençe where I have photographed it in company with fields of lavender. A well-published poppy image from my file shows an olive orchard, with silver leaves, underplanted with poppies and ox-eye daisies, the white ox-eyes making the mass of blood-red poppies sparkle.

However, the most spectacular poppy display I ever saw was along the roadside on the way from Fez to Marrakech, in Morocco. There I discovered a mountain of poppies, the vibrant flowers starting at the top of the mountain and descending to the road like an avalanche.

The Himalayan blue poppy is a hardy perennial rarely seen in North America because it cannot tolerate hot, humid summers. Some woodland gardens in coastal Maine and the Pacific Northwest have good displays, but it is mostly a feature of Scottish gardens, where it is most often seen in the company of beautiful pink rhododendrons and yellow bog primulas.

Rhododendrons: A book I co-authored with the late Fred Galle, North American rhododendron expert, *Azaleas, Camellias & Rhododendrons*, was the first to be endorsed by three plant societies—the American Rhododendron Society, the American Camellia Society, and the Azalea Society of America—making it a bestseller among garden books. These three major plant families were grouped together because azaleas and rhododendrons are of the same family (*rhododendron*), while camellias, which require similar growing conditions, often are used in partnership with both.

The most beautiful rhododendron and azalea pictures are those of well-established plants in woodland settings. I used to think that it was necessary to visit England and Scotland to see really superb rhododendron gardens, but I was surprised to discover a world-class rhododendron garden in North Salem, in upstate New York, at the home of

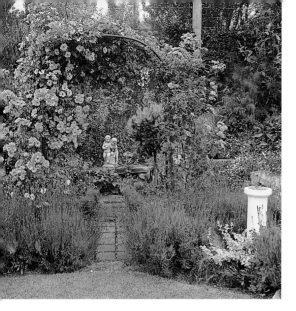

A beautiful small-space rose garden featuring climbing roses that frame a cherub sculpture. Complementing the roses are mostly flowering herbs such as lavender. Editors like examples of small gardens because more people have small spaces to work with, and "small" generally means less work.

Without doubt, roses are the most photographed flowers in the world.

rhododendron grower, Robert Carlson. It's all a matter of choosing the right varieties for your particular location, because varieties like the massive Walloper and black-eyed "Sappho" that abound in the Pacific Northwest struggle to survive in the Midwest and Northeastern United States. Indeed, many of the hardiest rhododendrons have been bred from North American varieties, mostly found growing in the Appalachia Mountains.

I once traveled the length of the Blue Ridge Parkway in early June and encountered *Rhododendron ponticum* growing across meadows and along wooded streams. Another time, on a trip through Wales, I was amazed to discover this North American native covering the slopes of Mount Snowdon, where it had escaped from local gardens and covered thousands of acres.

An often-asked question is, "What's the difference between a rhododendron and an azalea?" There's no botanical difference because all azaleas are really rhododendrons, but it has become customary among nurseries to refer to the smaller-flowered, fine-leafed varieties as azaleas.

Roses: Without doubt, roses are the most photographed flowers in the world. That's because they are a romantic flower associated with love, tenderness, and caring. Also, the flower form of many roses (especially the hybrid teas) has great substance, with voluptuous petals and high centers when captured in the "mature-bud" stage before the petals open out flat.

Almost daily, we see roses in countless different ways: on greeting cards, in calendars, jigsaw puzzles, and even candy boxes, displayed on shimmering satin pillows, in vases, through frosted glass, against artificial backgrounds, and a multitude of other fine and fancy variations. Many of these are creatively inspired and artistically done, although my best sales have always been with roses in natural surroundings. Finding symmetrical blooms with blemish-free petals is the biggest problem. However, many growers produce roses under glass for sale as cut-flowers; these are a source of perfectly formed blooms.

To portray roses for catalogs and garden magazines, it's important to know how different roses are classified. For example, hybrid teas generally are the largest flowered and grow one bloom to a stem. It's perfectly natural to show them singly, although I like to include a partly opened bud and a tight bud for aesthetic appeal. Floribunda roses, the next most popular group, hold their flowers in clusters, forming a spray of blooms; the best floribunda pictures show an attractive cluster. Miniature roses are popular for containers and usually create a dome of blooms. I like to see miniatures in attractive pots with something unobtrusive to give a hint of size, such as a string of pearls positioned on a vanity table beside the pot, or a sewing box with thimbles visible.

The most widely published rose image in my collection is actually an arrangement photographed in natural light indoors at the Renoir Garden & Museum, in the south of France. Renoir loved to paint roses because he saw in their colors the flesh tones he liked to paint of his models and children. When I walked into Renoir's studio, I noticed his easel with a replica of one of his rose paintings, and I realized that, for my book, *Renoir's Garden*, it would be best to have a bouquet of roses on a side table, as though the artist had just left the room to take a break.

In the nearby town of Antibes, I found a commercial rose grower who allowed me to walk through his greenhouses to choose blooms that were at the right stage of maturity and in a broad range of colors. That photograph has a special aura about it because the setting looks like a great artist's studio, with a Renoir nude just visible in the background. The image was seen by a fine-art printer and used to make a popular poster for framing.

Sunflowers: It is amazing how certain flowers can suddenly become in vogue. During the 1600s, the Dutch developed a special fascination for tulips, and huge prices were paid for any new variety that might capture the public's fancy. The public demand seemed insatiable, and investors traded on tulip futures like other commodities. The public's interest, however, suddenly waned and the "crash" brought ruination for many speculators.

Sunflowers are enjoying a surge of popularity that may last for many years, but then again may disappear tomorrow—to be replaced by some other flower "fad" like hydrangeas or poppies or even daisies. Breeders have invested much time in breeding new varieties. Every year I hunt for new ways to portray the sunflower, so I hope the demand stays strong.

In spite of the fact that there are many colors among sunflowers, including white, cream, red, orange, maroon, and bicolors, the image that sells consistently is simply a head-on shot of a big smiling yellow sunflower against a clear blue sky. Another popular image imitates one of Van Gogh's famous paintings of

sunflowers, with a cluster of large blooms arranged in a vase.

The head of a giant sunflower can measure up to 24 inches across, so there are good picture possibilities involving children. Also, any images of songbirds, such as cardinals and goldfinches, pecking the seeds from the head of a sunflower, are priceless.

Tulips: Alexander Dumas' classic adventure story, "The Black Tulip," told of intrigue, drama, and tragedy surrounding attempts to possess a unique black tulip developed in 17th century Holland. Today, black tulips are common, but the story was written of an era when tulip mania swept the continent of Europe. Discovered growing in the gardens of Turkish potentates, tulips were introduced into Europe by a Flemish diplomat. The Dutch developed a fanatical interest in them and built a flourishing industry that grows and breeds tulips to supply the world.

Mass plantings make great calendar pictures, especially when an historic house, barn, or old farmhouse is featured in the background. This field of giant sunflowers was photographed near my home, using a telephoto lens to fill the frame.

On cloudy days, tulip blooms often stay partially closed, presenting an urn-shape, but in bright light the flowers of many open out like a waterlily, presenting a greater density of color. This variety is "Pinkeen," also known as "Pink Emperor."

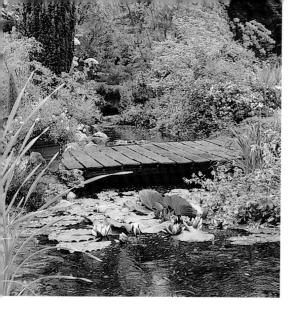

Hardy waterlilies growing along a stream at Clos Coudray, a beautiful cottage garden near Rouen, France. Splashes of rain help make this image especially appealing.

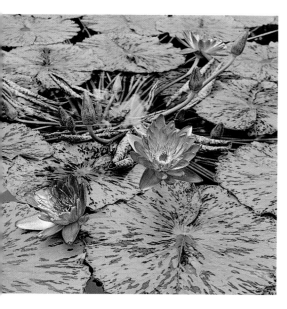

Tropical water lilies often have a month's extended bloom beyond that of hardy varieties, but they should be moved indoors to holding tanks to avoid freezing temperatures. The tropicals have the largest flowers, and often mottled leaves, like this "Albert Greenberg" variety.

Tulips come in a variety of shapes and sizes. Some look like peonies, some resemble waterlilies. Others have fringed or lacy petal tips, and some are striped. The Darwin hybrids are particularly photogenic because of their huge flowers and shimmering colors.

Picture variations with tulips are endless: massed in formal beds, naturalized on slopes, displayed in flower arrangements, as group close-ups and single close-ups, and seen as a sea of color in the propagation fields of Holland.

Most tulips are photographed best in bright but diffused light because they tend to open out their petals flat in bright sunlight and spoil their classic urn shape. An exception is the waterlily tulip (also called *Kaufmanniana*), which looks best with its petals splayed out like a waterlily.

The most extravagant tulip garden in the world is Keukenhof, located near Lisse, in Holland, about an hour's drive west of Amsterdam. There, almost a million people descend on the woodland garden during a three-month period to see the cavalcade of color produced from mostly tulips, sometimes in association with daffodils, hyacinths, crown imperials, anemones, and other flowering bulbs.

Waterlilies: Basically, waterlilies fall into two groups: the hardies and the tropicals. The hardies will survive winters in northern gardens, as long as their roots remain below the ice line; the tropicals need a water temperature above 70°F to feel comfortable and have a beautiful clear blue and a violet-blue, colors not yet available in hardies. Also, the tropicals are larger flowered and they make the most spectacular photographs. Some of the tropicals are day blooming and others are night blooming, although the night bloomers usually carry their flowers until mid-morning the following day.

By far the most spectacular waterlily is the Victoria waterlily, *Victoria regia*, and its hybrids. It grows huge, round lily pads up to six feet across. The leaves have upturned edges and a single leaf can support the weight of a child. The large white waterlily flowers open at night and smell like a ripe pineapple; they last two days and change color to pink and purple. Although native to the Amazon, the Victoria waterlily is grown extensively outdoors in northern gardens by being overwintered indoors in holding tanks.

Lotus blossoms are closely related to waterlilies and display flowers that can measure 16 inches across on stems up to six feet tall. Mostly pink and white, the translucent petals are awesome when backlit.

Most waterlily blues are hard to photograph "true to color" because of the *ageratum effect* (see "Problem Flowers and 'Anomalous Reflectance'" later in this chapter). The problem is most apparent on sunny days, less on cloudy days.

When photographing waterlilies in conservatories, watch for condensation on the camera lens, notably in winter months. This invariably occurs when you move quickly from the cold into a warm environment. To avoid foggy images, you must continually wipe the lens until it has warmed up. I once took a waterlily picture through a fogged lens and the surprisingly pleasant result was a flower with a diffused, "humid" look similar to the effect created by a soft-focus attachment.

With waterlilies, your choice of backgrounds normally is restricted to water or lily-pad foliage. A combination of the two works best if you have good sky reflections working for you. Avoid extraneous reflections in the water. Clouds, trees and anything else that's natural will help the image, while buildings, signs, and pool railings will spoil the composition. To get close enough to waterlilies without a telephoto lens, you may have to wade into the water; however, that often stirs up the bottom, creating an ugly, muddy surface. Patience rewards the photographer who also waits for a goldfish or beautiful koi to swim close to a flower. I often carry some breadcrumbs with me to attract fish when I anticipate photographing waterlilies.

Zinnias: Most annuals make spectacular flower pictures. Asters, coleus, geraniums, impatiens, marigolds, nasturtiums, pansies, and petunias are all spectacular during summer, with their mass displays and vibrant colors. However, zinnias are at the top of my list of photogenic annuals because they are large flowering and they offer a rich color range. The dahlia-flowered (with rounded petals) and cactus-flowered (with quilled petals) are in greatest demand, either in close-ups or massed in a stunning border partnered with other sun-loving annuals such as gloriosa daisies and petunias.

Butterflies and zinnias make good companions, and you normally will not have to wait long before one flutters to your group of flowers. Here is a special trick to ensure a greater chance of success: Catch a butterfly and place it in a jar in the refrigerator over night. The cold slows its metabolism, and you will be able to pose it anywhere you wish. The sun soon warms it, so it can fly away, unharmed.

If it's hummingbirds you wish to attract for photography, choose red or orange flowers. Zinnias are rich in reds, but it is the tubular flowers of red petunias, red nasturtiums, red salvias, and red nicotiana that are the strongest draw for hummingbirds. The first two weeks of August are a particularly good time to concentrate on hummingbird photography because they are finished nesting and begin preparations for migrating south by gorging themselves on sweet nectar.

Other Photogenic Garden Flowers: Choosing the 20 most photogenic garden flowers was difficult. On a more extensive list, I would also include bromeliads, camellias, hellebores, fuchsias, gladiolus, hibiscus, passion flowers, primroses, and proteas.

A key to successful flower photography is knowing the flowering dates for the most photogenic classes, and knowing where to find them, making flower photography a year-round-pastime. Camellias, for example, bloom from November through March in southern gardens. Proteas are a South African flower that is becoming popular in coastal locations; September to October usually is the time to catch them blooming in the misty wilds near Capetown. Hibiscus flower year-round in tropical regions like Florida and Hawaii; even greenhouses in temperate climates make them readily available in pots throughout the year.

Swallowtail butterfly on zinnias. To pose a butterfly on a flower, catch the butterfly and place it in a jar in the refrigerator overnight. This slows down its metabolism sufficiently for you to place it wherever you wish, before its body is warmed by the sun and it is able to fly away.

A beautiful floral pattern is formed by the flowers of winter aconites against a light sprinkling of snow.

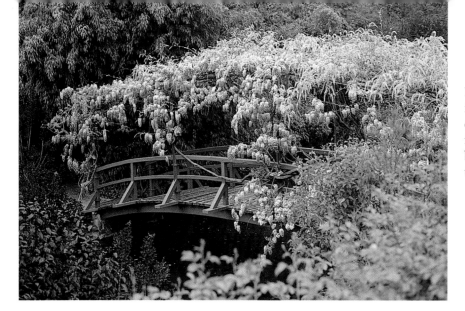

Monet's bridge photographed in diffused light when a cloud briefly obscured the sun. The diffused light is advantageous here because it blocks infrared rays, producing a true blue for the wisteria blooms.

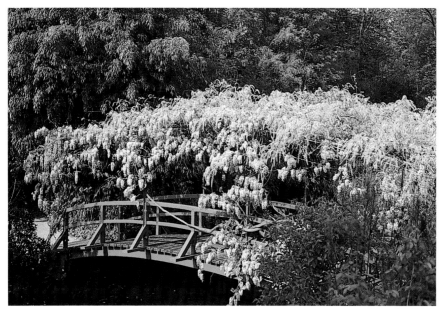

This photograph of Monet's bridge in bright sunlight is not a good image because the wisteria flowers turn pink and look "bleached."

Patterns with Flowers and Leaves

Whenever I see a mass of flowers or leaves, I instinctively look for patterns. You see them used as covers for books and garden magazines, as posters, and as photographic art for framing. Patterns are most often formed by petal shapes and leaf or branch configurations. When you discover an interesting one, it's generally best to shoot it so the design extends to all four corners of the frame, "bleeding" off the edges.

I have also found patterns in a grove of birch trees, the slender, arching leaves of grasses covered in frost crystals, the fronds of ferns, and even the tracery of exposed roots—but nothing beats flowers and colorful leaf formations for dramatic impact. Not common, they fill me with wonder because several special elements must come together to produce the best patterns. These include a perfect symmetry of flowers or leaves, a spontaneous design quality, and most flowers or leaves usually must be on the same plane so the complete arrangement is in sharp focus. In most cases, diffused, even lighting is also necessary, although I have taken some appealing pattern pictures with backlighting.

Problem Flowers and 'Anomalous Reflectance'

Color photography is a miracle of technology. With the use of just three basic dyes, color transparency film produces a remarkable rendering of most colors, providing the film is fresh, correctly exposed and processed promptly.

Some blue flowers can present a serious problem with any film. This is known technically as *anomalous reflectance*, or the *ageratum effect*, because it is most noticeable when photographing the flower known as *Ageratum houstonianum*, the floss flower. Instead of blue, the film records the color as pink or purple. Regardless of its name, the problem stems from the fact that film sees colors differently from the human eye and is more sensitive to the infrared end of the spectrum where the human eye has little or no sensitivity. The problem is most noticeable to the naked eye under bright sunlight, and less in shade or diffused light.

Suggestions for photographing difficult blue flowers:

• Mount a mid-blue filter over the camera lens. A light-blue filter offers insufficient improvement, and a deep-blue filter produces too much of a blue cast over the entire image. The mid-blue filter makes the required correction with the least obvious bluing of the overall image.

• Shoot in shade or under an overcast sky. With some flowers, such as cinerarias and iris, this can improve the resulting image significantly.

Ageratum demonstrating the problem of "anomalous reflectance." Photographed in bright light, the flowers show a pink cast on film.

Ageratum showing color correction when shooting through a mid-blue filter, which produces a more realistic blue coloration.

The Ageratum Effect

Here are some of the blue flowers that exhibit the *ageratum effect*:

Ageratum, Asters, Anemone, Aubretia, Campanula, Cineraria, Clematis, Hyacinth, Iris, Larkspur, Lobelia, Morning Glory, Pansy, Petunia, Phlox, Scabiosa, Stokesia, Tradescantia, Viola, Waterlily

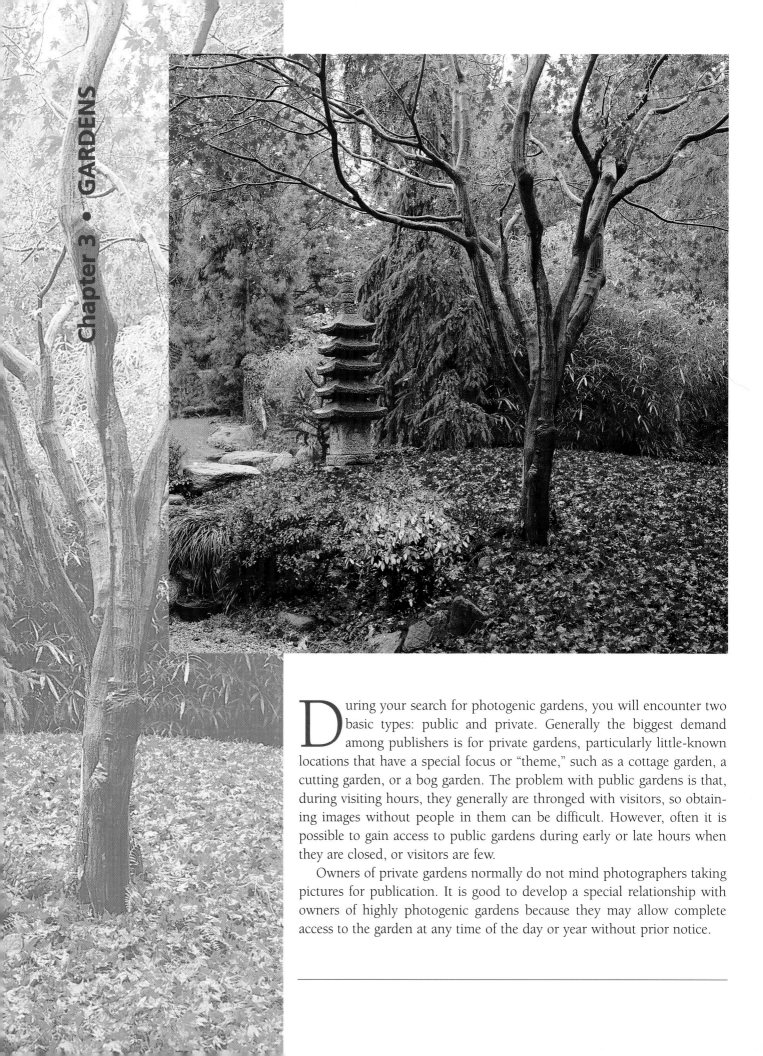

During your search for photogenic gardens, you will encounter two basic types: public and private. Generally the biggest demand among publishers is for private gardens, particularly little-known locations that have a special focus or "theme," such as a cottage garden, a cutting garden, or a bog garden. The problem with public gardens is that, during visiting hours, they generally are thronged with visitors, so obtaining images without people in them can be difficult. However, often it is possible to gain access to public gardens during early or late hours when they are closed, or visitors are few.

Owners of private gardens normally do not mind photographers taking pictures for publication. It is good to develop a special relationship with owners of highly photogenic gardens because they may allow complete access to the garden at any time of the day or year without prior notice.

How to Avoid Clichéd Images

When you look at postcards showing views of public gardens, you will get a good idea of "clichéd" images, usually spring or summer scenes of green leaves and flower borders, or garden structures such as a gazebo, the garden flooded with light against a blue sky with puffy white clouds. These may please tourists, but they don't win awards because the best photographs of gardens capture the "ephemeral" moments often caused by fleeting atmospheric conditions.

Although gardens may at first appear to be "static," every garden offers a constantly changing scene, not only from season to season, but from minute to minute when the light and mood become an integral part of the composition. When I visit a garden for the first time, I like to be at the site early, even before the sun comes up. Often you will see spectacular sunrise

To get the best landscape images, rise before the sun is up. That's when you can be rewarded with a tranquil view like this, of echiums growing beside Monterey Bay, California, with a cool sea mist in the background.

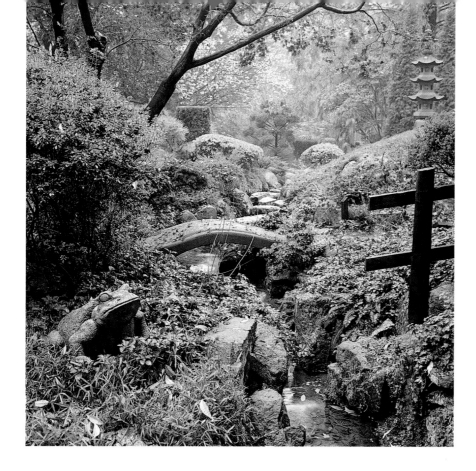

Autumn is a season of rich colors and mist. This image of the Japanese garden of Swiss Pines, near Philadelphia, captures the season perfectly. A light rain shower has helped to intensify the foliage colors and make the rocks shine. You may want to deliberately wet down stone accents in a garden, especially flagstone.

scenes, with the sun glinting low on the horizon through leaves, creating long shadows across lawns, making shafts of light through trees, and causing vibrant reflections on water.

Also, early morning often produces wisps of mist and imbues the landscape with cool colors. Consider shooting from angles offering front lighting, side lighting, and especially backlighting. When you find a really outstanding garden, visit the property often—on frosty mornings, at noon in saturated sunlight, at dusk when infrared rays invade the light, on rainy days, cloudy days, bleak days, bright days, humid days, and during every season. Tour every corner, take every walk, look at the garden from all angles, and examine every planting scheme. Check out interesting shapes, buildings, and design features, particularly those that combine plants and structures, such as morning glories twining through an ornate gate or chestnut blossoms framing a bridge. Most importantly, look at everything through the viewfinder and "compose, compose, compose."

When I first photograph a garden, I like to know from the owner what he considers the basic design philosophy. For example, he may consider that the garden has an ethnic influence, perhaps traditional Japanese, an English cottage garden, American Colonial, or Italian baroque. Or he may consider the garden to have special areas, such as a water feature with exquisite reflections, a spectacular rock garden, an ingenious herb garden, a sculpture collection. Or, the garden may be famous for its plant collection, such as azaleas and rhododendrons, daffodils, tulips, or irises. Knowing the garden's strengths ahead of time helps you decide an appropriate time to visit. Sometimes a garden such as Monet's Garden is so eclectic, you can visit virtually at any time

The Valley Garden at Swiss Pines Japanese garden in spring and winter. In spring, early-flowering azaleas and the fresh, bright greens provide a strong sense of the season, with a stone tower providing a good focal point. The presence of the tower allows a direct comparison from season to season. Editors like to show gardens photographed in different seasons.

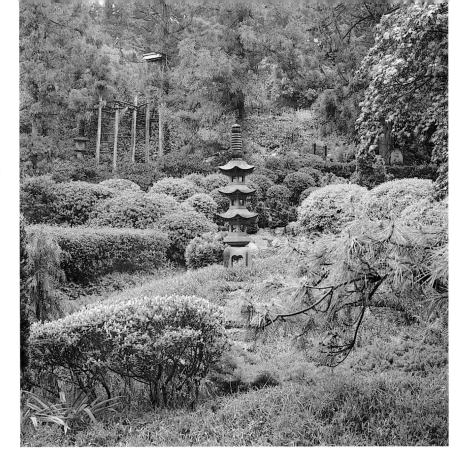

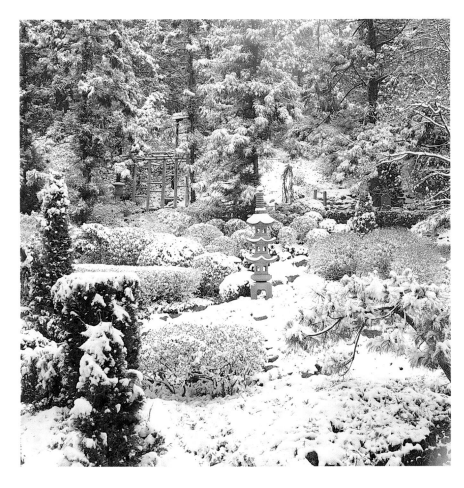

Tour every corner, take every walk, look at the garden from all angles, and examine every planting scheme.

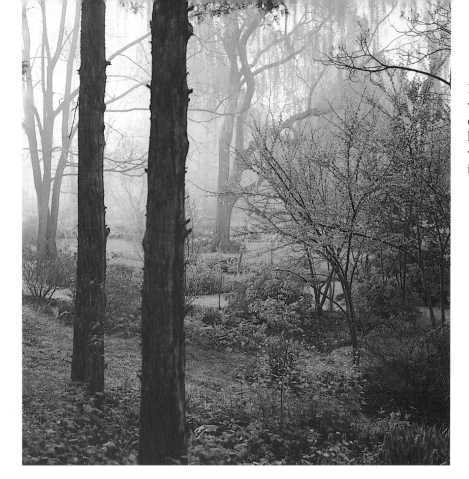

Flowering redbuds in early spring, with the sun not only starting to penetrate the early morning mist, but silhouetting the leaves of a weeping willow in the background for a feeling of peace and tranquillity.

to get good pictures. But even Monet considered his garden to be at its peak when the bearded irises bloomed, and usually there was one particular day that he could judge the irises to be at their best!

To cover a garden well, you need to consciously seek several different types of composition:

• Try to show the entire garden—an overall view—or give it a "sense of place" by also including some of its surroundings, such as a mountain range,coastal cliffs, or a crowded city center. For maximum sharpness, the general rule is to set the camera lens on infinity.

• Then look for specific views within the garden, particularly self-contained design elements, such as a double perennial border with an arbor at the end, a productive vegetable garden, or a lake with a romantic bridge and pond-side plants. I rarely shoot these pictures at infinity, preferring to focus on something definite such as a gazebo in the middle ground or a vivid clump of flowers in the foreground. If there is a choice, usually it is better to focus on the foreground feature and allow the middle and background components to be softer.

• Finish up a shoot with three types of close-ups: Show specimen plants with the entire plant or with a group of flowers visible; single blossoms, leaves, or berries; and macro close-ups with the petals bleeding off all corners of the frame.

These are the "essentials" for a good garden feature, but I also like to include a view of the house and a portrait of the owner in the garden (see *Chapter 10*, Plant People).

Garden Accents

Examples of good landscaping elements are popular with publishers. In the world of landscape architecture, design elements such as brick paths, stone walls, and wooden decks often are referred to as "hardscape," and all the plants are called "softscape." Although plants by themselves can make a pretty picture, to be appealing, hardscape elements generally need to be in association with plants, for example, a picket fence with flowering vines growing through, a flagstone path with creeping thyme or moss growing between the joints, or a decorative urn with cascading petunias spilling over the brim.

Be aware that stone often looks best under a cloudy sky after a light rain shower and, when photographing benches or gazebos, it's not only important to show the placement of the feature, but also the view that it is meant to provide. You may have to "prep" some hardscape features to make them look good, for example, by clustering a group of container plants on a deck so the deck doesn't look bare, or placing some stylish chairs and a table on a terrace.

The combination of hardscape and evergreen plants, such as hemlock hedges and boxwood edging, is often referred to as the "bones" of a garden. It is important to show these features so the design can be appreciated. Often this requires shooting from a high angle such as from an upstairs window, or using a high ladder, or even a helicopter! Also, a wide-angle lens may be required to show the "bones" of a garden adequately.

Lawns & Groundcovers

Lawn grass seed and lawn grass products represent a huge industry, so pictures of showcase lawns are in constant demand for advertisements and package designs, as well as for magazine articles. Be aware that lawns in different areas of the country are grown from different turf grass varieties. Kentucky bluegrass, bentgrass, and improved perennial ryegrass lawns are prevalent in the north and provide the most luxurious look, while fescues are used in light shade. Coarser grasses are popular in the south because of their drought resistance. These include zoysia, Bermuda grass, St. Augustine grass, and buffalo grass.

Photogenic lawns should show a pleasing contour as well as an attractive medium-income family house in the background, and some color from neatly cultivated flower beds.

Where lawns are difficult to grow, such as slopes and deep shade, many gardeners resort to using groundcovers like English ivy, carpet phlox, and periwinkle. Wherever you encounter a good use of a groundcover, try to shoot it with an interesting structural element. For example, include stepping stones, steps, the edge of a path, or a water feature.

Oriental Gardens

When I first visited Japan and Taiwan, I was unprepared for the beauty of their gardens. Although I had visited a number of Oriental gardens in other parts of the world, few came close to capturing the exquisite beauty and tranquil atmosphere of a genuine Japanese or Chinese garden. Even the best imitations in other parts of the world often resort to pseudo-Oriental elements such as placing Chinese dragons in Japanese gardens. And nowhere have I seen the luxuriant use of moss as in the city of Kyoto, with its moist climate.

Much of the appeal of an Oriental garden is in the details, because every stone, tree, trickle of water, bark texture, and ground contour is shaped or placed with infinite care. Also, Japanese gardens exhibit a lot of symbolism, using rocks that resemble animals, and creating illusions with shapes.

The best Oriental gardens are located in and around Kyoto, Japan, where they are referred to collectively as the Imperial Gardens because they date back to 1620 when they were planned by members of the Japanese Imperial Court. The most famous is the Katsura Imperial Garden. Here, you must purchase a ticket for a specific day and time, and you will be conducted around the garden with a guide, in the manner that emperors of old conducted their privileged guests around the garden.

You should have a basic knowledge of Japanese garden design to photograph Japanese gardens. Most of them are known as "stroll gardens," with a path that twists and winds around a stream or lake, presenting a visual adventure and artistic compositions at every turn. Evergreens generally make up two-thirds of a Japanese garden because the old garden masters not only liked to see foliage in winter but conifers can be trained into weathered shapes, and camellias and rhododendrons have leaves that shine in the pale, wintry light. Most Japanese gardens are designed

around the principle of a "cup" for introspection. Usually, a pond, pool, or lake serves as the bottom of the cup and the pondside plantings its sides. As the path encircles the water feature, there are observation places to look at a special vignette, such as a boulder forming a rocky island, islands of floating waterlilies, or a lantern on a promontory.

Another type of Japanese garden is designed for meditation, usually from a fixed observation point such as a balcony or deck. These meditation gardens can be very small, simply presenting a tapestry of evergreen foliage effects in combination with boulders and a water feature. The best of these gardens allow the landscape to look exquisite at every season, especially when covered with a light coating of snow.

Japan has a distinct change of seasons, similar to North America, usually with snow in winter, bright greens in spring, lush foliage in summer and a blaze of russet colors in fall from carefully chosen deciduous trees like ginkgos and Japanese maples.

Color in a Japanese garden is dignified, with pastel pink waterlilies, clumps of blue flag irises, a grove of flowering cherry trees. Water and stone are vital ingredients, the water often orchestrated to create a wide range of effects from a broad sheet called "falling cloth," to narrow trickles called "silver threads." The most ingenious water device I ever encountered was an arching jet of water emerging from a bamboo pipe from high overhead that splattered onto rocks far below, splintering into tiny droplets of spray and creating a double rainbow!

Much of the appeal of an Oriental garden is in the details, because every stone, tree, trickle of water, bark texture, and ground contour is shaped or placed with infinite care.

Some Favorite Gardens

Over the past 35 years, I have photographed many well-known and unknown gardens, each presenting a different challenge. With well-known ones like Monet's Garden, the trick is finding scenes other professional photographers have overlooked or failed to appreciate. With unknown gardens, there is a thrill in being the first to present a garden with "star" qualities, although I must admit that generally only one in ten private gardens ever turns out to be publication quality.

When you find a beautiful private garden, or discover a new way to photograph a well-known garden, try to keep it a secret. Other photographers will descend on your discovery and plagiarize your work! On my first visit to Monet's Garden, I shared my special insights with another photographer, who followed me like a shadow and was able to publish before I could!

Here are some examples of both famous and little-known gardens, and how I photographed their special qualities. To find the better-known gardens, refer to directories such as *The American Garden Guidebook*, *The Garden Tourist*, and *Gardenwalks*.

Magnolia in the Mist

Historic Magnolia Plantation, near Charleston, South Carolina, is one of the world's most beautiful public gardens, almost as old as the Imperial Gardens of Kyoto, Japan. The flowering peak at Magnolia Plantation occurs

To obtain this high-elevation view of a rising sun reflected in a pond at Magnolia Plantation, South Carolina, I used a ladder to climb on top of a storage building to frame the reflection with the blossoms of a flowering plum tree. An elevated viewpoint invariably improves overall garden scenes, especially those with water reflections.

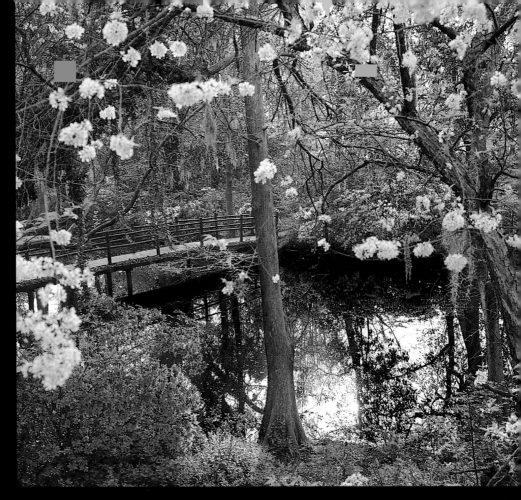

Reflections can double the beauty of a garden! For this shot at Magnolia Plantation, I stood on the arch of a bridge and focused on the reflection instead of the margin of the pond or surrounding plants to obtain a sharp image.

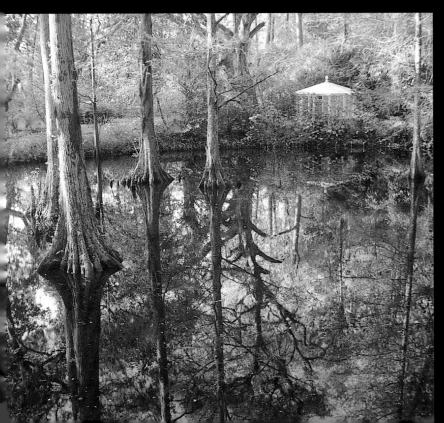

Wildlife can enhance a garden scene. Here, geese contemplate a pond in Deerfield Garden, Pennsylvania, with an arched bridge, azaleas and exquisite water reflections all helping to create a beautiful, spontaneous composition.

in early March, with the extravagant flowering of thousands of azaleas that mingle their vibrant blossoms with those of vining blue wisteria, glittering white dogwoods, pink flowering peach trees, yellow Lady Banks roses, saucer-size white Cherokee roses, and trumpet-shaped white atamasco lilies.

Established in the 1600s as a rice plantation, the gardens are laid out around a southern swamp, with tall, moss-shrouded cypress trees and massive live oak trees. They shade a series of mirror-smooth lakes that not only produce exquisite reflections, but invariably produce an early morning mist, offering ghostly silhouettes and muting the petal colors.

Because Magnolia Plantation has been the subject of numerous editorial features, to produce something different from the usual clichéd images of flower beds and paths for *Veranda Magazine*, I concentrated on capturing Magnolia in the mist. This not only included views along the enormous live oak avenues leading up to the mansion, but views along the river walk edged in azaleas, and of several gazebos and bridges placed strategically beside several lakes. The resulting article won an award for Best Magazine Photography from the Garden Writers Association of America, one of three I have been privileged to receive for photography of Magnolia Plantation (in addition to one in *Connoisseur* and another in *Americana*).

Magnolia is on the "hit list" of every garden photographer. And no wonder: At its flowering peak, it has a unique romantic quality, with a dreamlike, naturalistic aura. I believe that, over the years, my images of the garden have produced more revenue for me and more publicity for the garden than any other photographer. As a result, I have developed a close friendship with the owners, the Drayton-Hastie family, who provide a comfortable guest cabin within the gardens for me to stay so I can be there at all hours.

(Left) I shot the maze at Deerfield Garden using a cherry picker to gain height, and a wide-angle lens to show the pattern of boxwood hedges. An overcast day helped eliminate shadows from nearby trees from falling across the design.

A distinctively designed English teak bench makes a good focal point in a woodland setting at Deerfield Garden. A strong sense of spring is produced by flowering azaleas and freshly unfurled leaves of trees in the background.

Deerfield's Maze and Valley Garden

My first photography of Deerfield Garden, near Philadelphia, Pennsylvania, was an assignment for *Architectural Digest* (October 1981) when I shot in spring, at the height of the azalea display. When the owner, H. Thomas Hallowell Jr., chairman of Standard Pressed Steel, saw the resulting article, he invited me to work with him to produce a book entitled *Deerfield Garden - An American Garden Through Four Seasons*. In addition to winning a Best Book award from the Garden Writers Association of America, selections of the book's photography were published in *Connoisseur*, and in many calendars. The book also won me an assignment from Temple University Press as the exclusive photographer on a subsequent work, *Gardens of Philadelphia and the Delaware Valley*.

The Deerfield book involved a year of photography, covering all the seasons. The advantage of being able to work in a garden year-round is that compositions can be photographed from the same viewpoint so comparisons can be made, especially the contrast between spring and winter, and spring and autumn. Fortunately, I lived within an hour's drive of the garden, so I could stop in during times when special atmospheric conditions occurred, such as snowy days and when the fall foliage was at its peak.

Although Deerfield Garden features many elements, including a fabulous boxwood maze that is a replica of the hedge maze at Hampton Court Palace in England, what seemed to set Deerfield apart from most other private gardens were its incredibly beautiful vistas—especially views of a valley garden, shooting through trees, across a lake and along a meandering stream, allowing images to show infinite depth. Even in gardens that incorporate a lot of design features, it generally pays to concentrate on showing one aspect of the garden particularly well. Good vistas are hard to find, so featuring Deerfield's in every season gave the book its award-winning status.

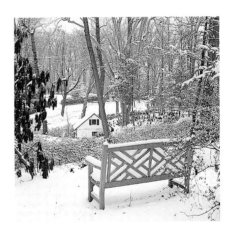

The same bench makes another beautiful subject, this time in winter, when snow emphasizes its slatted design.

Deerfield Garden in autumn. Generally, woodland gardens are most photogenic in fall colors, when a placid pond or lake can be included to contrast with a riotous leaf canopy.

The main feature of Ted Nierenberg's garden is a lake that he has surrounded with trees to produce exquisite autumn coloration. Morning and late afternoon light produce the best effects.

Cobamong's Autumn Extravaganza

Ted Nierenberg, retired founder of Dansk dinnerware, is a keen gardener and accomplished photographer who built a beautiful contemporary house overlooking a lake near Westchester, New York. He worked miracles on the landscape, especially with trees and shrubs that produce intense fall color, and meandering paths that offer wonderful viewpoints. Ted produced a beautiful book, The *Beckoning Path*, in collaboration with garden writer Mark Kane, that documented his garden through four seasons using his own photography, and some inspiration from my book, *Deerfield Garden*.

Photographs showing gardens in autumn coloration are in big demand among publishers. After reviewing Ted's book, I realized that it was the garden's fall display that could produce the best images during a one-day shoot. Ted called me when he thought the fall colors were at their best, and I started out my three-hour drive at dark to be in the garden early enough to obtain some misty qualities to my pictures.

I wanted to capture the feeling of a fabulous woodland garden, so I concentrated my efforts not only on dramatic color combinations from the deciduous trees, but also lake reflections and contrasts of bark and leaves—especially the ghostly white bark of New England white birches that Ted

had strategically planted around the lake while he was developing the garden. Also important was showing the beautiful contemporary Scandinavian-style house he had built with commanding views, but artfully integrated within the woodland setting.

A problem with photographing woodland gardens is showing some order out of the organized chaos. Although patterns with leaves can look beautiful, it usually is best in woodlands if you seek "leaf tunnels" where the trunks and arching branches of trees meet high overhead to create a leafy avenue or "cathedral" effect. If you shoot along a path, invariably you will not only capture the tunnel sensation, but also the long, narrowing sense of perspective produced by the path. This helps to draw people into the picture. Because the owner had made a path completely encircling the lake, I set up my camera wherever the path led through an interesting foliage display.

Footpaths are an important garden feature as they draw the viewer into the picture.

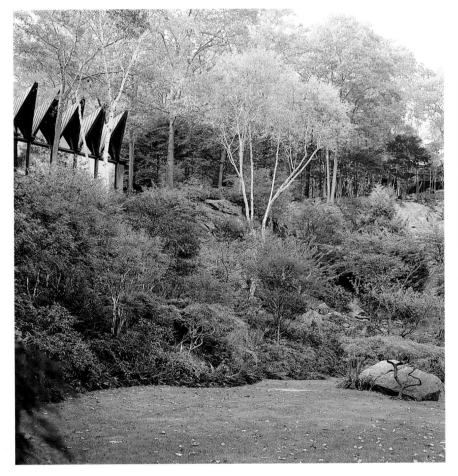

When photographing a garden for publication, include a house if possible because readers like to relate the garden to the residence. This is a beautiful, modernistic residence built by Ted Nierenberg, founder of Dansk Dinnerware, at his property, Cobamong, New York.

Always be alert for beautiful contrasts produced by decorative tree bark. This paper bark birch, *Betula papyrifera*, is planted strategically so the graceful lines can be viewed from a balcony of the house.

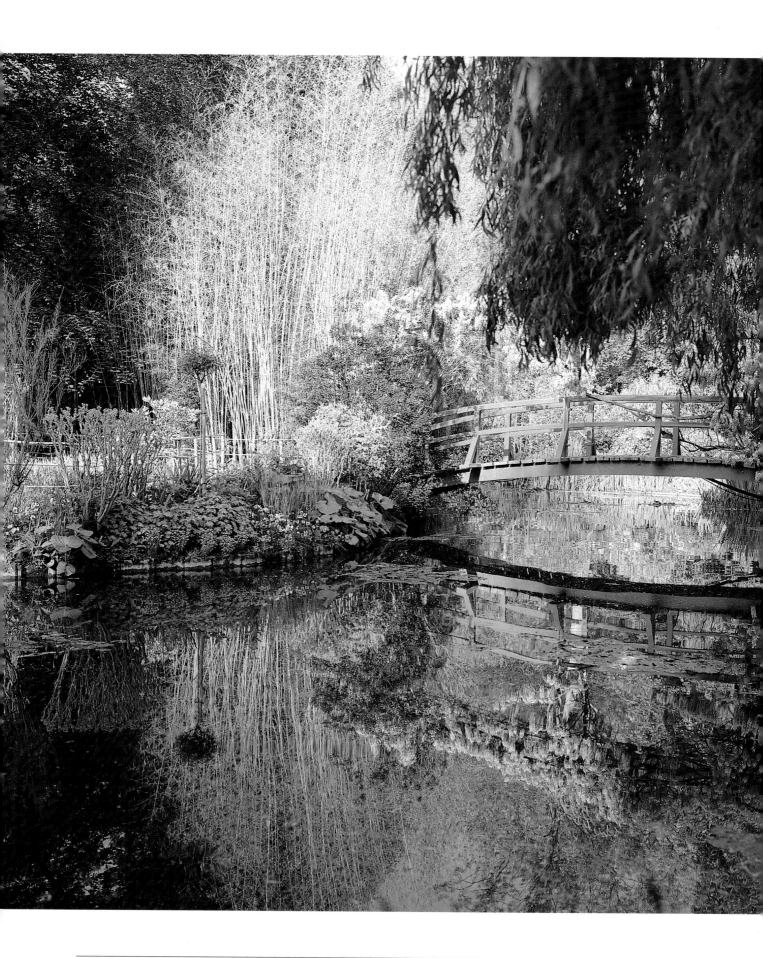

(Opposite page) After more than ten years of photographing Monet's Garden in all seasons and all kinds of weather, I finally found the right conditions to capture the water reflections as I had always wanted to see them. The time is early morning, with the sun just beginning to penetrate the garden; it's early May, with wisteria blooming on the Japanese bridge. This image has a "painterly quality" and captures the essence of Monet's water-garden design better than any other image I have seen.

Secrets of Monet's Garden

I first became interested in the gardens of the great French Impressionist painters in 1970 when Lila Acheson Wallace, founder of *Reader's Digest*, announced the donation of a million dollars to restore Monet's Garden. But it wasn't until May 1988 that I visited Monet's Garden and recognized elements that had not been photographed previously, particularly some of Monet's special color harmonies and the sensation of shimmer that he brought to his garden. Shortly after photographing Monet's Garden, I was invited by the French Tourism Office to shoot Renoir's Garden, near Nice, in the south of France. The images were published initially in *Architectural Digest*, and then in a book I authored, *Renoir's Garden*.

Following the success of *Renoir's Garden*, I was then invited to write a book by publisher Friedman/Fairfax, who realized that Monet's methods had not been revealed. For its size, Monet's Garden, in the village of Giverny (just north of Paris), is probably the most widely photographed garden in the western world. Studying the work of other photographers in books and magazines, I was amazed that no one had successfully portrayed the specific design elements that Monet used to create what he described as his greatest work of art. My book, *Secrets of Monet's Garden*, was the first to reveal through photography the extent of Monet's gardening genius and his unique methods.

Because Monet was always insecure about his work, and secretive about his garden philosophy, it required months of careful research to identify more than 100 specific planting schemes that set his garden apart. These included not only special color harmonies such as yellow-and-blue, silver-pink-and-red, and blue-pink-and-white, but the most incredible visual effect of all: the sensation of shimmer.

Monet's flower garden is distinctly different from his water garden in that the flowers are planted more profusely, and are intended to create special color harmonies. Here, pink roses and red geraniums combine with green leaves and a dash of silvery foliage from dianthus edging the beds, to create a dramatic, mostly monochromatic, color harmony. Monochromatic plantings can feature plants of all one color, or several colors in the same tonal range, like shades of red and pink.

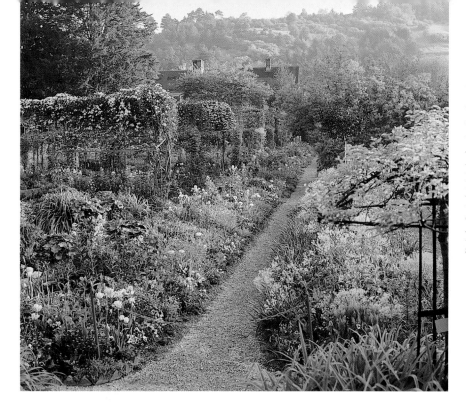

Invariably, people take overall views of Monet's Garden from the top floors of the house. This overall view, from the bottom of the garden, was made while I was standing on a pile of hedge trimmings in a gardener's truck. It shows more clearly the pronounced lines of perspective that Monet deliberately used in his design to give paintings of the garden infinite depth and the sensation of shimmer.

The canopy of Monet's arched footbridge presents a beautiful pattern of vines, struts and wisteria flowers against rich foliage contrasts of copper beech and bamboo.

Monet divided his palette into "hot" colors and "cool" colors before painting, and took the idea into his garden. This is a hot-color planting, using mostly orange, red, and yellow wallflowers to make a bold color combination. Taken on my first visit, in spring 1988, it has become the most widely published of all my images of Monet's flower garden.

Initially, the "Impressionist shimmer" was a phenomenon early Impressionist painters used to make their paintings unusually vibrant. Often this was with flecks of white next to bolder colors to make the bolder colors shine in the same way that, in nature, lupines and delphiniums often have white centers to make their blues brighter than a solid color alone. I learned that Monet introduced the Impressionist shimmer into his flower garden in several ways: first by planting lots of airy white flowers to simulate "glitter" in the landscape, then by draping airy white flowers on tall trellises to create a "lace-curtain" effect, and by including lots of bicolored flowers, especially tulips and irises with white parts to the flower.

Following the success of *Secrets of Monet's Garden* as a hardcover book, I was invited to produce a calendar for Portal Publications, which has sold successfully in the gift shop at the Monet Museum. My most treasured possession is a letter from the head gardener, in French, complimenting me on the photography.

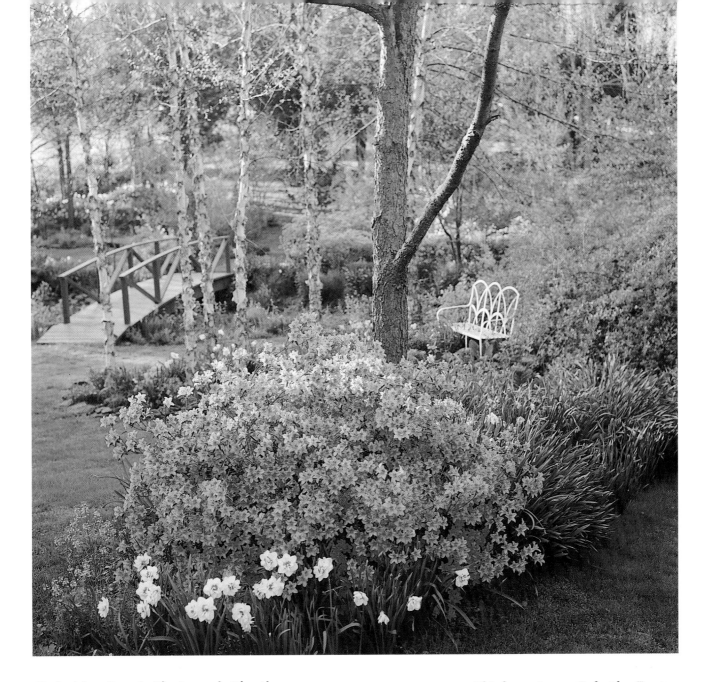

Cedaridge Farm's Photogenic Plantings

Just as Monet planted his garden to paint, I have planted my garden to photograph. I feel it should be the goal of every serious horticultural photographer to establish a garden, no matter how small, to serve as an "outdoor studio." You are then likely to find that plantings you create yourself will sell more consistently than any others. That is because there is as much a demand for small garden schemes as there is for ambitious ones, and in other people's gardens you don't often have the luxury of being able to move plants around, rearrange ornamental elements such as birdbaths, and have the scene available for shooting through all the daylight hours for days, weeks, and even months. Although my own 24-acre garden, Cedaridge Farm, allows me plenty of space to create special plantings, an area as small as a sun deck or a shady terrace can also serve as an "outdoor studio," allowing an infinite variety of container plantings.

This lawn vista at Cedaridge Farm shows a red bridge across a stream, with lavender-pink azaleas in the foreground, double-flowered daffodils complementing the azalea blossoms, and tall, honey-colored river birch providing strong structural accents.

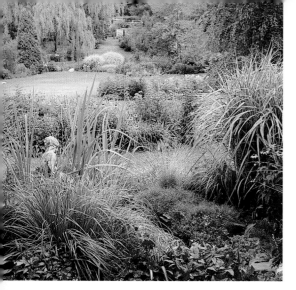

I use my home, Cedaridge Farm, as an "outdoor studio." The property has 24 acres of sloping ground, partly meadow and partly wooded, with 20 theme gardens for me to work in. This beautiful lawn vista, from the doorway of a breakfast room, shows a series of perennial beds descending a grassy slope to a pond.

Cedaridge Farm is located near Gardenville, Pennsylvania, in an area of farmland where the change of seasons is dramatic: cool, mint greens in spring; hot and humid enough in summer to grow superb crops of tomatoes, melons, and peppers; intense russet colors in autumn, and winters that invariably bring plenty of snow. This allows me to not only compose small-space garden schemes for book and magazine illustration, but also to shoot large landscapes for calendar publication.

With the help of my wife and a groundskeeper, I have opened up 22 theme areas, which include several shade gardens, sunny perennial borders, a waterlily pond, stream, bog garden, vegetable garden, orchard, cutting garden, and cottage garden. As certain flowers come in and out of vogue, I can make plantings galore, or change them as needed. For example, when sunflowers were all the rage, I planted dozens of varieties in every sunny space. These were followed in popularity by poppies, and I was immediately on the market with many variations of poppy plantings to satisfy the demand.

More significant is the opportunity to create special color harmonies. Many publishers are no longer satisfied with gardens that show an haphazard assortment of plants. They want pleasing combinations like Monet planted: blue and pink flowers together; yellow and blue; red, yellow, and orange; an all-white garden; all-red; all-blue, and other permutations.

In addition to providing a place to stage pictures, the garden itself has been featured in numerous magazines, including *Architectural Digest* (June 1994), *Gardens Illustrated* (December 1995), *Fine Gardening* (July 1996), and *The Journal of the Royal Horticultural Society* (March 1997).

Increased sales of photography justify the expense of employing a full-time gardener and other related costs such as fertilizer. (For visiting times, see Appendix, page 144).

Exquisite foliage effects from "Bowles Golden" grass, variegated hostas, and sweet woodruff help produce a tapestry of greens in a heavily shaded area at Cedaridge Farm.

The combination of fragrant, yellow angels trumpets in the foreground and blurry autumn highlights in the background provides a strong sense of the season, as well as identifying an old-fashioned "Victorian"-style garden space at Cedaridge Farm.

Just as Monet planted his garden to paint, I have planted my garden to photograph.

Spiky foxgloves in company with peonies thrive in a shade garden in front of a barn and paddock at Cedaridge Farm. Planting details like this are important in garden features for publication.

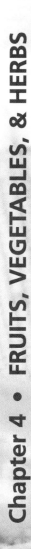

The most salable images of fruits and vegetables show them on the vine: apples on trees, red ripe tomatoes growing among blemish-free leaves, and asparagus spears striking through the soil, for example. There is a much lesser demand for off-the-vine arrangements where the fruit of the harvest is shown as a still life. There is also a big demand for "example gardens" that show bountiful gardens in an appealing design, or healthy flowers, fruit trees, vegetables, and herbs all growing in perfect harmony.

On-the-Vine Images

Ripe apples, pears, and peaches can indeed look beautiful arranged in baskets or on a dinner plate as though prepared by a gourmet, but Mother Nature has millions of years of experience presenting wholesome, sun-

(Opposite page) No vegetable makes a more colorful presentation than the pepper. This image shows mostly hot varieties, which have the widest color range and the most interesting shapes.

This image of a Mediterranean-type melon, photographed as a table arrangement using natural light, was used for seed-packet illustration.

ripened fruits and berries still clinging to the vine. Naturally, there are exceptions: Any fruit or vegetable that looks more appealing on the inside than on the outside should be removed from its habitat, cut open and made into a pleasing arrangement showing cut and uncut fruit together. Examples are melons displaying their luscious orange, green, or red flesh, and pea pods exposing the neat interior rows of peas. The plant's leaves and branches make a good background against which to pose the picked fruit.

Invariably, when photographing on the vine, you will encounter a heavy shadow under the fruit, especially on a sunny day. You can wait for a cloud to diffuse the light and eliminate the shadow, or bounce light into the shadow area with a reflector.

Avoid blemishes on leaves as well as on the fruit. If leaves in the background show spoilage by fungus disease or insect damage, remove them and replace them with healthy ones.

For apple pictures to sell, you should include heirloom varieties as well as modern kinds, photographed on the tree. This is an old variety called "Winter Banana," showing a bountiful crop against a clear blue sky.

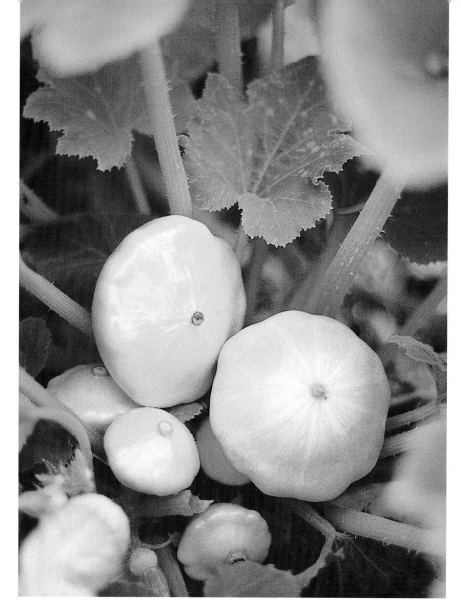

Publishers generally prefer "on-the-vine" pictures. This is a summer scallop-type squash called "Sunburst," clearly showing the way it grows.

In addition to close-ups of fruit, seek good specimen pictures showing the entire plant, as well as unconventional uses for fruit trees; for example, as a hedge, in containers such as whisky half-barrels, espaliered against a wall, or trained to create an arbor. There is a big demand for fruit trees as lawn accents, with a middle-income house in the background, and as orchards—especially if the orchard has wild-flowers covering the ground, or there is a seasonal quality such as a spring flush of blossom, and the same composition showing ripe fruit in fall.

Catalog houses always seek good images of dwarf fruit trees, especially with children or an attractive woman holding baskets of fruit picked fresh from the tree.

When photographing apples or pears on a branch, make the colors brighter by gently polishing the fruit before taking the picture. Chemical sprays and dust accumulation on the skin can dull the color considerably. Other fruits, such as plums and grapes, form a "bloom"—a dusky, powdery coloring—on the skin. This bloom is natural and should not be removed; otherwise, the fruit will look fake. Nor should you over-handle this kind of fruit because fingermarks and shiny patches will spoil the picture. At harvest shows, judges give extra points for grapes and plums showing a healthy bloom.

Off-the-Vine Images

Some vegetables are impossible to shoot in their natural state. One example is root crops that must be pulled from the ground. Generally, it is necessary to clean away soil particles and photograph the subject with its leaves intact. A spray bottle filled with plain water can be used to make the skin sparkle. Even beets have an attractive sheen when sprayed lightly with water.

Another type of off-the-vine image in moderate demand is the montage of different varieties of one class of fruit or vegetable. This can be arranged flat against a plain background to create a poster quality, or in a tight grouping. For example, sweet corn is a family of vegetable with a vast color range. The mature cobs can be arranged to create an informal pattern, or placed shoulder-to-shoulder for direct comparison of colors and shapes.

Even seemingly mundane vegetable categories such as beets, lettuce, and cabbage can be surprisingly colorful when different varieties are collected together. Beet varieties are red, purple, white, and gold, and if the roots are sliced through, it's often possible to extend the color range by showing yellow and candy-striped interiors.

Similarly, with cabbage it's possible to bring together varieties with not only green leaves, but red and blue, and to vary the leaf texture by including savoyed and wavy-leaf kinds. The color range can be extended further by introducing other edible members of the cabbage family, including pink and white ornamental kale, and bronze-leaf mustard.

The color range of corn is almost as colorful as peppers, especially the ornamental variety known as "Rainbow." This image is used repeatedly for seed-packet illustration.

This display of blackberries was photographed at Cedaridge Farm and arranged on a table in the garden. Searching flea markets for "props" like old wheelbarrows, wicker baskets, and wooden crates to use in arrangements can be fun.

Variety Selection

Publishers often want to show a large selection of varieties photographed individually. The wider the selection of varieties you can offer, the better the chance for multiple sales. Some fruits and vegetables run to hundreds of varieties—especially strawberries, tomatoes, peppers, and apples, all of which are in constant demand. But don't concentrate only on modern varieties commonly offered by garden centers. There is an equally big demand for heirloom, or pre-World War II, varieties that are best found in historical gardens and botanical gardens, or by growing your own with seeds from specialty heirloom suppliers.

Giant Vegetables

Show someone a giant vegetable and watch a smile come. There's something whimsical about giant vegetables. Several points are important to consider if you want dynamic pictures: The most important is to provide a sense of scale so people can appreciate the size. Usually it is best to show a person, preferably the proud grower of the vegetable, because this gives the picture added news value. Be sure to get the individual's name and the vegetable's weight or dimensions.

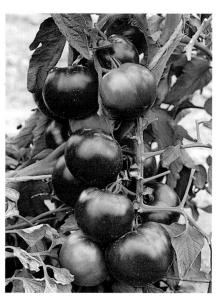

Heirloom tomatoes are very popular, but sometimes it is difficult to show any distinctions among the different kinds. Not so with the variety known as "Rainbow," which has yellow and red marbled skin.

"Supersteak" is a beefsteak variety of tomato that produces heavy yields and an opportunity for especially good "on-the-vine" images. Plants loaded top to toe with blemish-free leaves and fruit delight most editors. Staked plants sell better than unstaked.

Images of giant vegetables are in big demand; try to include a person in the picture to provide a sense of scale. When you use your own children (this is my son, Derek Jr. with "Simpson Elite" lettuce), you don't have to fuss with model-release forms. Posing the model behind the subject helps to emphasize the size.

For a true indication of size, have the individual hold the vegetable close; to exaggerate size, have the person hold the vegetable at arm's length toward the camera.

Herbs

Although some herbs have beautiful flowers, such as lavender and chives, most do not. The challenge is to make something beautiful out of a bunch of stems and leaves.

One way is to shoot the subject with something colorful, such as green mint leaves against silvery artemisia or golden oregano in the background. Another way is to shoot the subject in a decorative container on a deck or patio of stone or brick. There is also a steady demand for pictures of herbs showing a specific use: lavender with a colorful potpourris in the composition, mint as an infusion with a teacup and teapot; horehound with a jar of candy canes.

Example Gardens

Generally, there is more creativity the design of herb gardens than vegetable gardens. However, the French have developed some picturesque ways to present vegetables in potager gardens, which often include low edgings made from wattle fences, blocks of vegetables

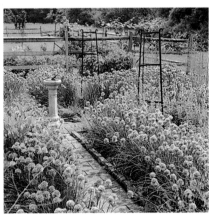

Presented here are two different views of the same small-space herb garden at Cedaridge Farm. It is laid out in a "quadrant" design, with a brick path dissecting the square plot into four smaller squares, and a sundial in the middle. Note how the lighting differs according to time of day. Left is a late afternoon view, with pink-flowering chives backlit by a setting sun. Right shows the same garden from a higher elevation in bright light, giving a better sense of design.

laid out in patterns like the Chateau Villandry, and decorative forcing jars made from terra-cotta. In a Scottish garden, I discovered frost-protectors using old street lamps, adding a good decorative accent to otherwise mundane row plantings.

When editors feature vegetable gardens, they not only like to see a strong sense of design, but also a theme. For example, the gourmet restaurant, Sook Harbor House, on Vancouver Island, British Colombia, features a wide selection of herbs, vegetables, and edible flowers such as nasturtiums and calendulas in such close proximity to the Pacific Ocean that it is possible to capture images of the edible landscape with the rocky coastline in the background.

Generally, vegetable gardens should be photographed from a high angle to show the layout of vegetable crops. This view of a low, walled vegetable garden at Cedaridge Farm shows a gardener's cottage in the rear to introduce a human presence, often requested by editors.

Harvest Scenes

Publishers often require harvest scenes as chapter openers for books, and also to illustrate articles dealing with a particular fruit or vegetable, such as winter squash, apples, sweet corn, peppers, and tomatoes. They also seek harvests of mixed vegetables that provide a sense of the season: lettuce, asparagus, cauliflower, radishes, rhubarb, peas, and cabbage for an early spring display; tomatoes, peppers, melons, and onions for a summer display; and squash, pumpkins, sunflower heads, popcorn, kale, and raspberries for an autumn display. Use some imagination, like photographing a vegetable medley in an antique wheelbarrow against old, weathered barn siding; pumpkins and squash on a carpet of fallen leaves with a scarecrow on a haycart. Collect antique garden tools such as rusty weighing scales, seed scoops, metal buckets, and wicker baskets, to use as props in these harvest scenes.

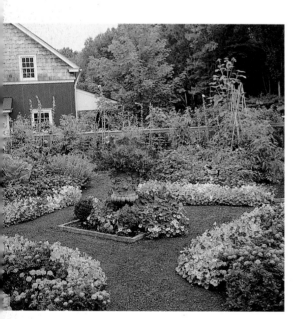

A presentation of herbs showing different varieties and different kinds of composition. Although editors mostly prefer specimen plants in a garden setting, there is also demand for the herb presented as a table arrangement, showing a "use." Because many herbs are weedy-looking, you may have to be creative to make them look appealing. Others, such as nasturtiums, have beautiful flowers that light up any garden. (Left) Nasturtiums, (Center) Greek Oregano, (Right) Basil

Pumpkin displays present endless opportunities for good calendar pictures, especially when an old barn or spring-house can be shown in the background.

Woody plants—trees and shrubs—tend to be the most dominant life forms in the landscape. Often a particular tree can identify a specific environment more successfully than any other feature in the landscape. Moreover, the mere silhouette of a tree can identify a specific location; for example, a saguaro cactus immediately identifies the Sonoran Desert, a date palm a Saharan oasis, coconut palms a tropical island, live oaks draped in Spanish moss a Southern plantation, and rows of bushy lavender the district of Provençe, in France.

Although trees such as tulip poplars and magnolias have blossoms that compare with any beautiful garden flower, trees offer greater opportunities for photography in their sculptural branch configurations, leaf formations, and bark textures. For the book *Renoir's Garden*, I concentrated on showing the beauty of 500-year-old olive trees, with their gnarled trunks and near-human characteristics.

Saucer magnolias produce enormous quantities of flowers in spring but generally the display is fleeting because they tend to flower at a time when frosts can kill the flowers. Note how fallen petals on the ground help enhance the beauty of this composition, with the flowers of several trees bleeding off all four edges of the frame.

Seasonal Differences

A desirable picture sequence is a series of garden scenes depicting the four seasons: the monochromatic tones of winter, the pinks and bright greens of spring, the reds and deep greens of summer, and the oranges and yellows of autumn. The sequence is most effective when you can include a design element, such as a gazebo, while still focusing on the changing colors in the landscape; the structure provides an essential point of reference that does not change.

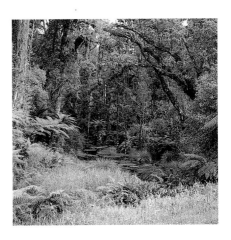

Rain forests are wonderful places to photograph trees. This grove of tree ferns surrounding a pool was beside the main highway leading into Fiordland National Park, New Zealand.

Here are some tips concerning each season:
- **Spring:** Seek out ornamental trees and shrubs, such as flowering azaleas, cherries, crabapples, dogwoods, and rhododendrons. These bloom at the height of spring and can be photographed in company with each other, as well as with many spring-flowering bulbs (such as yellow daffodils) and wildflowers (such as blue woodland phlox and white trilliums). Often, you'll find these growing beside sparkling streams or ponds that may heighten the sense of "springtime freshness," particularly when a mosaic of colors from flowers, leaves, and sky can be captured among water reflections. Because spring is a season of bright greens from unfolding leaves, backlighting is often a good way to enhance those greens. Apple, peach, and plum orchards can create a galaxy of blossoms and beautiful lines of perspective in proximity to old barns.

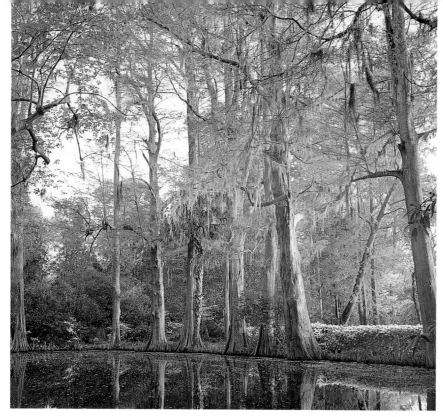

Magnolia Plantation, South Carolina, is a woodland garden with lakes that produce exquisite reflections. I like to be in the garden early, when light from the nearby Ashley River slants into the garden through immense cypress trees that arch over the water like the columns of a cathedral.

Often it helps the composition when shooting trees in the wild—whether at the edge of a field or beside a lake—if you can use foreground branches and leaves to "frame" the main scene. Although fall foliage displays seem to last for weeks, often there is a particular day when the colors peak. The day after I took this view of lake reflections at Cobamong Garden in New York, strong winds and rain stripped the trees.

•**Summer:** Although the number of flowering trees diminishes, conifers and other needle evergreens can present a tapestry of color in the landscape, notably the blue atlas cedar and yellow gold-lace cypresses. Crepe myrtles have vibrant colors in summer, especially in southern states, while many shrub roses continue blooming. The leaves of most trees turn dark green, making them good framing elements. Blue, pink, and white hydrangeas make striking summer subjects, especially in coastal locations where they tend to grow best.

High heat, glaring sun, and humidity often conspire to dull foliage greens on film in summer. To negate the dulling effect, use a polarizing filter. Mid-day light is often too garish, creating too much contrast among tree shadows, so look for early-morning and late-afternoon lighting effects, which include long shadows across lawns from trees at the edges of property, and shafts of light streaming through branches.

• **Autumn:** This is the season for striking leaf colors, berry displays, fruit and nut harvests, pine cones, and seed pods. It's a perfect time to seek out gardens with sugar maples, Japanese cut-leaf maples, tupelos, sarvistrees, and birches for their intense reds, yellows, and golds. Above all, look for cultivated landscapes with water features, and important structural elements such as bridges, stone walls, and split-rail fences to add a sense of scale.

Avoid sunny days. For the sharpest colors, save your photography for days with a high overcast sky. If you can shoot after a light rain shower, you will find this intensifies fall colors even more. Don't overlook "carpeting" effects from fallen leaves. This often means waiting until the end of the fall season to catch colorful leaves on the ground, as well as in the tree canopy.

Snow helps accentuate trees. However, be sure to shoot before the clouds clear because bright sunlight often ruins a snow scene involving trees. Here you see a mature apple tree at Cedaridge Farm, with part of a cottage garden and bench in the foreground. I designed this part of the garden deliberately to look good under a mantle of snow.

• **Winter:** The monotone moods of winter create stark contrasts against mellow skies. Look for interesting bark textures, branch configurations, and special atmospheric effects caused by coatings of ice, snow, mist, rain, and heavy frost. Visit Japanese-style gardens where structures and artistic pruning of trees and shrubs produce outlines in the landscape that are accentuated under a light covering of snow. Shoot trees silhouetted against winter sunrises and sunsets. Explore for waterfalls, both free-flowing and frozen; also evergreen hedge mazes, parterres and topiary figures that can look highly animated when coated with a fresh fall of snow.

Shooting in Snow: Be alert for good snow scenes whenever there are trees in the landscape; woody plants can take on unusual sculptured qualities when coated with snow. Be aware, however, that photographing landscapes covered in snow requires a different discipline than shooting the same scene in other weather conditions.

First, there are many kinds of snow—from a light sprinkling that dusts the landscape like icing sugar to heavy snows that can almost suffocate the land. Also, there are different light qualities to contend with: the dark period from a thick mantle of cloud when it is actually snowing; a brief, brighter period after the snow stops and the clouds start to thin; and finally comes a glaringly bright period when the clouds completely clear and the sun shines.

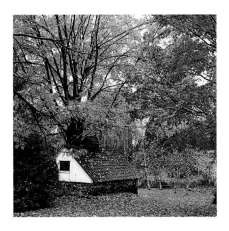

An old springhouse with a slate roof catches fallen leaves from a grove of sugar maples at Cedaridge Farm. Fallen leaves were left on the ground deliberately to create a colorful carpet. When all the leaves have dropped, they are swept up and delegated to a compost pile so they don't rot the grass.

In my experience, the best time to shoot gardens as snowscapes is while it is still snowing and soon after it has stopped—but before the sun breaks through. Once the sun comes out, the strong glare causes the camera's light meter to underexpose the subject, resulting in an undesirable dark image. In this case, compensate by "bracketing" exposures. Because it is difficult to judge the exact amount of compensation required, bracket three exposures, at 1 stop, 1-1/2 stops, and 2 stops more exposure than the meter reading.

Once it has stopped snowing and the clouds clear, there can be a beautiful coating of ice on branches, offering particularly good backlit snow scenes. But you must react immediately because the ice can disappear quickly once the clouds clear and a breeze shakes the snow off the branches, or the sun melts the ice away.

Compositions that Sell

Whether trees are alive or dead (lying across a path or stream), young or old (with deeply fissured bark and hollowed trunks), their beauty changes not only from season to season but from moment to moment from the fleeting moods of nature. A tree's capacity to charm the eye can be limitless; only when it has crumbled away into a pile of compost will a tree finally fade from the scene. I classify salable tree and shrub pictures according to three main types requested by publishers:

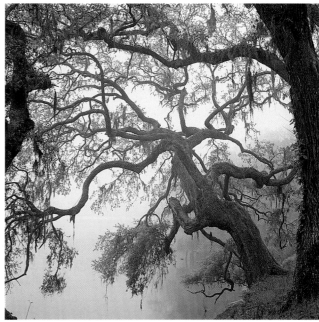

Bodnant Garden in North Wales has the most impressive tree and shrub plantings I have ever seen. Here, I show the magnitude of the garden by aligning an immense California redwood tree with azaleas on a far slope.

When photographing trees, size impresses. Few trees present a more ghostly aura than live oak trees garlanded with Spanish moss and shrouded in mist, as seen here at Magnolia Plantation. This image helped win an award for an article entitled "Magnolia-in-the-Mist" in *Veranda* magazine.

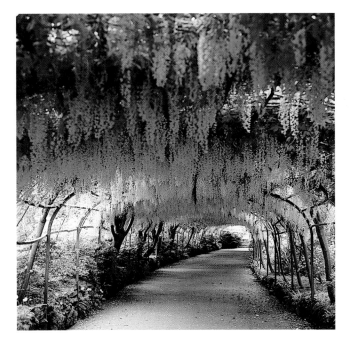

The famous "laburnum tunnel" at Bodnant Garden is difficult to shoot without hoards of people walking through it. Patience is needed to find a break in the crowds to show the shadow patterns along the path.

A sensational, yet simple, plant partnership involving the yellow leaves of a grape vine in fall coloration, and a red-berried pyracantha.

- **Artistic:** Examples include a grove of trees silhouetted against a stormy sky, a mass of gleaming peach blossoms presenting a galaxy of pastel color, a silent rain forest shrouded in mist, white aspen trunks striking through golden leaves in fall.

The objective is to produce a visually exciting picture expressing a particular mood, and relying on dramatic contrasts or slight subtleties of color, patterns, and unusual camera angles. Old age in trees is a strong source of artistic images. Look for gnarled old olive trees contorted into strange shapes, redwood trees cloaked in lichens and moss, century oaks with massive spreads and limbs garlanded with resurrection ferns or Spanish moss.

Bristlecone pines in the White Mountains of California are believed to be the world's oldest living organism, some of them surviving more than 8000 years. They are twisted into beautiful shapes by the arid conditions of the region, their sinuous, textured trunks presenting stunning contrasts with the majesty of the mountain terrain.

The ancient baobabs of tropical Africa were one of my main reasons for visiting the Kruger National Park region. I discovered the biggest trees in lion country and was advised to clap before leaving the safety of my Jeep. At the sound of clapping, any lions hidden in the long grass would raise their heads up. When the coast was clear, I then had barely 15 minutes of shooting outside the Jeep before the driver started shouting, "The lions are coming!"

Exquisite plant partnerships with trees and shrubs are not easy to find. This companion planting of blue wisteria and blue ceanothus at Powis Castle, North Wales, exhibits a flawless beauty.

• **Specimen Shots:** These can be almost clinical in appearance, preferably showing a single healthy tree, lit evenly from the front against an uncluttered background such as a clear sky or a front yard of a middle-income house. Avoid distracting elements such as children's playsets and telephone wires.

Specimen pictures should show a definite shape because all trees have an identifying outline. Most trees look best photographed in spring when foliage colors are crisp, but if a tree is known for fall foliage, show it in its autumn coloration. If there are any other significant ornamental features, such as the prominent flowers of a horse chestnut, show these on the tree prominently to have a salable image. You will find the best tree and shrub specimens in arboretums, on golf courses, within parks, and the front lawns of suburban neighborhoods.

• **Close-ups:** Many trees have qualities that are best appreciated in close-ups. Examples are the peeling bark of a eucalyptus tree, the intricate leaf pattern of a thread-leaf maple, and the generous berry clusters of a mountain ash. Often these are used by publishers as "insets" in combination with a specimen picture.

Flowering Trees & Shrubs

The beauty of most flowering trees is usually fleeting. Although flowers may appear on a tree for two weeks, a peak period of bloom typically lasts only a day. This is true of some flowering cherries with delicate petals. Many times I will discover a flowering tree just past its peak and make a note to return earlier the following year to capture it at peak perfection. Some of the most desirable flowering trees and shrubs include cherries (spring), crabapples (spring with fruits in fall), crepe myrtles (summer), dogwoods (spring with fruits in summer), laburnum (spring), magnolias (spring), redbuds (spring), rhododendrons (spring), roses (spring, summer, fall), and wisteria (spring).

Shade Trees

Although flowering trees are more colorful when photographed at the height of their blooming period, don't overlook the value of trees grown to provide cooling shade during summer. These normally have a spreading or billowing shape (willows), and some have multiple trunks (New England birches). With shade trees, editors favor special varieties with ornamental qualities that make the benefit of shade a bonus; for example, decorative bark, a variegated leaf, or a purple-leaf form.

This is a list of shade trees I have sold repeatedly, and the time of year they are most photogenic: ash, mountain (late summer when berries ripen); beech (spring); birch, New England (spring, summer, fall); ginkgo (spring, fall); honeylocust (spring); maple (spring, summer, fall); oak (spring); pine (spring); silk tree (summer when flowers appear), and weeping willow (summer).

Hedges

Publishers always seek good examples of shrubs and trees used as hedges and windbreaks for privacy and screening. In addition to attractive examples, such as showing the hedge on a diagonal, it is also desirable to illustrate its functional use, such as screening a patio or providing shelter from wind for a vegetable garden. Obviously, flowering hedges such as camellias should be shown in full flower, while hedges like burning bush, noted for fall colors, should be shown in autumn after the leaves have changed color.

Decorative Bark and Branches

Trees and shrubs with decorative bark and branches are grown mainly for winter enjoyment, so it is a good policy to obtain images of these in a wintry landscape as well as other seasons. For example, the flaking bronze bark of the paperbark maple and the honey-colored bark of "Heritage" river birch stand out in the landscape at all times, but the red branches of a red-twig dogwood and coral-twig maple usually are hidden when the plants are in leaf, so winter is the better time to show their intensive coloration.

American holly is an evergreen tree with berries that persist through winter, looking especially beautiful when coated with a fresh fall of snow.

Berry Displays

Trees and shrubs with beautiful berries are delightful photographic subjects because the berry display often extends into winter months when the berries can be shot against a snowy landscape. Consistently good berry displays are produced by berberis, coralberry, cotoneaster, crabapples, dogwood, firethorn, hawthorn, hollies, and winterberry. Complete berry gardens are so scarce that I had to grow my own so I could photograph several varieties against fall leaf colors. With a telephoto lens, it's possible to capture cardinals and bluebirds feasting on them.

Evergreens

Although deciduous trees offer greater potential for stimulating pictures because they are so varied in their shapes and leaf colors, evergreens provide good contrasts and backgrounds against which to view the fleeting flowery components of gardens. There are actually two groups of evergreen: broadleaf evergreens such as hollies, camellias, and rhododendrons, with the advantage of glossy dark leaves; and needle evergreens, also called conifers, such as junipers, pines and yews, with slender leaves. Both types bear flowers but the broadleaf rhododendrons and camellias, for example, are bolder than the sometimes insignificant catkin-like flowers of conifers. However, some of the conifers do bear interesting seed-bearing cones that generally mature in fall.

Many arboretums have special areas devoted to collections of evergreens. These are good places to obtain specimens for the file, but it is in the wild that evergreens shine, such as the coastal cliffs of Monterey Peninsula, where you can see Monterey cypresses and Monterey pines growing within sight of the Pacific Ocean, sometimes swirling in mist or soaked by salt spray, and sculptured by nature into bizarre shapes.

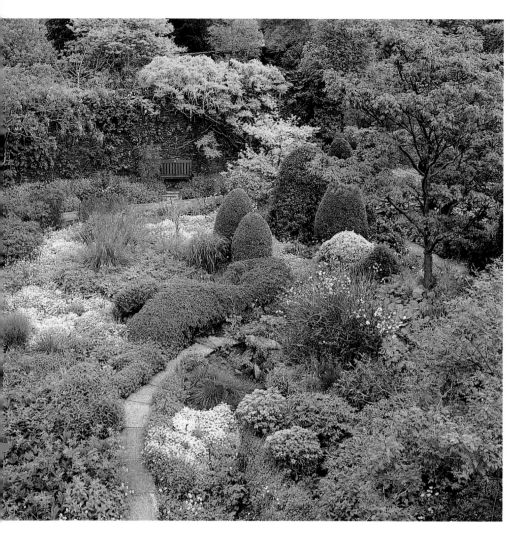

The Garden House, Cornwall, England, has a tower with a winding staircase to its top at the center of the garden. From there, it is possible to shoot stunning overall views of the garden with its blend of trees, shrubs, and perennials. Shot on Fujichrome Velvia film, you can see that the yellows are more vivid than reality.

Bonsai

The art of bonsai is a method of pruning trees to keep them small by confining their roots to shallow containers called bonsai trays. The best bonsai specimens are trained to simulate specimens that have been weathered by wind in harsh environments. Pose bonsai specimens in a garden against a beautiful lawn, rockery, waterfall, or statuary, and photograph them under various light conditions. Morning mist and a setting sun can create an exquisite atmosphere.

Bonsai subjects generally are displayed outdoors during frost-free months. They are moved indoors for protection during winter months, where they often are staged against Japanese woodblock prints showing paintings of mountain ravines and pounding seas.

Topiary

The art of topiary, which is the clipping of trees and shrubs into animated forms, is a familiar feature of European historic gardens, but scarce in North America. Nonetheless, the Ladew Topiary Gardens near Baltimore, Maryland, which I photographed for an early issue of *Southern Accents* magazine (Fall 1982), is the biggest topiary garden in the world. Its equivalent in Europe is Levens Hall, England, which I also enjoyed photographing for its greater sense of antiquity and larger pieces.

There are two kinds of topiary: "instant" topiary, where vines and creepers are trained over wire forms, for completion during one or two seasons depending on the rate of growth of the creeper, and "pruned" topiaries that can take generations to reach maturity. Pruned topiaries are in more demand by publishers. Topiary is best photographed in spring when the new leaf growth makes the subject look more alluring and healthy, although I also enjoy visiting topiary gardens after a fall of snow because the figures then seem to become more animated.

Two views of the topiary gardens at Levens Hall, in the north of England. The image to the right shows the impressive topiary forms photographed with a standard lens. The image below shows the same view of the garden photographed through a telephoto lens that "compresses" the distance between the topiary figures.

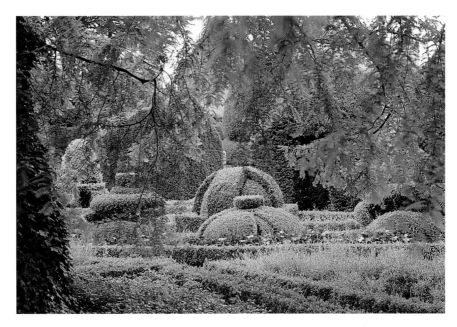

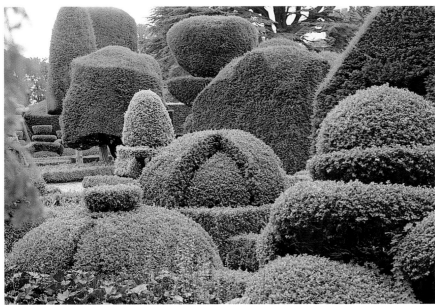

Tropical Trees and Shrubs

When visiting tropical areas of the world, be alert for exotic tree specimens such as swaying palms, gigantic rubber trees, and rambling vines that are part of a lush landscape. Although many of these can be found in the wild, often they are encountered in public and private gardens.

Some tropical trees are incredibly free-flowering. The blue jacaranda tree is native to Brazil and often used as a street tree in California, blooming in spring. In Hawaii, the African tulip tree covers entire hillsides.

Surely, the most exotic of all tropical trees is the royal poinciana, which is a favorite of gardens in the Bahamas. When I was assigned by *Architectural Digest* to photograph "The Garden of the Groves" on Grand Bahama Island, I learned that they had a veritable forest of these magnificent red-flowering trees, so I planned my photography when the royal poincianas were in full flower.

Always try to shoot tropical trees showing a "sense of place," such as coconut palms growing along a section of pristine beach; a rubber plant growing among the ruins of a Balinese temple; New Zealand tree ferns in a ravine.

W ildflower photography requires more patience and ingenuity than other forms of plant photography because many wild-flowers are not showy except in extreme close-ups. The beauty of some is fleeting, and the density of color can vary from year to year, depending on environmental conditions, such as abundant rainfall at time of seed germination.

The objective of wildflower photography is to produce as natural a composition as possible; the best pictures will be those that show not only the color, shape, and form of the plants, but also the environment in which they grow, such as a desert, prairie, woodland, or wetlands. It would be inappropriate to shoot the native wild arum, known as jack-in-a-pulpit, with a clear blue sky as the background—even if you found one growing that way—because it is a denizen of moist woodlands. Therefore, a shady aura is needed and, if possible, the sparkle of water in the background to suggest its need for moisture as well as shade.

(Opposite page) Seek out wildflower gardens in early spring when most wildflowers bloom. This beautiful informal garden in Stamford, Connecticut, combines native dogwoods with masses of blue Jacob's ladder, blue forget-me-nots, and pink woodland phlox to create a predominantly pink-and-blue color harmony.

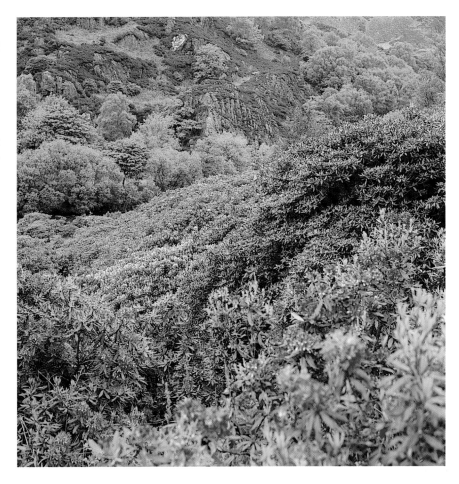

Spring Wildflowers

North America is fortunate in having a rich assortment of indigenous wildflowers. The best displays tend to occur in Texas, Arizona, and California, following winter and early spring rainfall. Regardless of location, spring usually is the busiest time for wildflower photography because many photogenic wildflowers grow, flower, store food, and set seed even before the trees are in full leaf. Blue Texas bluebonnets and orange California poppies can cover hundreds and thousands of acres across treeless hillsides, and the azalea and rhododendron displays of the Appalachia Mountains are spellbinding along woodland streams and misty ravines.

As spring rolls into summer, all kinds of wayside flowers compete for attention, such as delicate blue chicory, the bold yellow of black-eyed Susan, swamp sunflowers, and pink bee balm.

In fall, a multitude of blue asters, swamp sunflowers, purple ironweed, and yellow goldenrods light up the landscape, combining their colors with wild berries, the bursting seed pods of milkweed, and fall foliage. To emphasize the fall season, it's often necessary to rise early to capture vast sweeps of these wildflowers with mist lingering above the ground.

Fungus, wild mushrooms, toadstools, ferns, mosses, and lichens are yet another world of beauty to explore. I have found few plants more symbolic of spring than the unfolding fronds of fiddlehead ferns as the sun penetrates leafless trees to warm the forest floor.

I thought I would never see wild rhododendrons (*Rhododendron ponticum*) more beautiful than along the Blue Ridge Parkway in North Carolina—until I visited Snowdonia National Park in North Wales. There I found the same rhododendrons covering the mountainsides in even greater profusion, even though the plant is not native to that area. Often their magenta color is jarring in a sunny garden but, muted by mist in a rugged natural landscape, they are an uplifting sight.

Jack-in-the-pulpit is a woodland wild-flower with a hooded flower spathe that is best photographed from a low angle so the spathe can be backlit.

Indian paintbrush photographed in partnership with beach asters at Point Lobos National Park, California. The orange and blue make a good color combination.

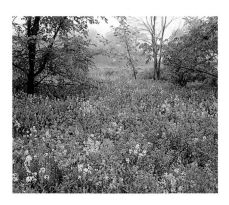

Although dames rocket is native to Europe, it is widely distributed throughout North America, having escaped into the wild from home gardens.

Even weed photos can produce a good income. Dandelions are considered noxious weeds, yet I sell pictures of them time and again, not only as examples of lawn weeds, but for their edible qualities. Their flowers can be harvested for wine, their young leaves make good salad greens, and the root is used medicinally, so it is a plant that is described frequently in books on lawn care, in plant encyclopedias, and herbal books.

Because many of the most interesting wildflowers grow in shade, you will find that a cable release and a sturdy tripod are essential accessories. You should also be sure that your tripod can be used to position the camera at ground level—many can't. Finding wildflowers can be a problem, not only because development continues to shrink wildflower habitats, but because overgrazing by deer is also wiping out many established populations. Fortunately, many parks and wildflower preserves are fenced to keep out deer. One of the best is the Bowmans Hill Wildflower Preserve, near New Hope, Pennsylvania.

You may also want to consider turning a part of your garden into a wild garden. Sunny areas are good places for prairie gardens and sunny rock gardens, while shade can provide conditions for woodland wild-flowers, and boggy areas a suitable wetlands environment.

Areas of the world noted for spectacular wildflower displays include Morocco, South Africa, the Himalayas, Western Australia, and New Zealand's Sub-Antarctic Islands. When photographing in these regions, it is essential not only to obtain lots of close-ups showing the wildflower species, but also to show the extent of the wildflower displays—and especially to provide a sense of place with some overall landscape views that might include vast sweeps of grassland, mountains, or a coastline.

Edible Wayside Plants

It is important to show the entire plant with a little background so the viewer can clearly identify the plant. A good close-up of the edible part, such as tuberous roots of ginseng or the berries on wild cranberries, is also essential. With edible mushrooms, turn one over to reveal the underside of the cap because it is the underside that often is the identifying feature.

Poisonous Plants

Publishers frequently do features on poisonous plants. Some come in and out of the news, usually after a child or a foraging group has suffered symptoms of poisoning from eating berries or mushrooms that look edible, but actually are poisonous. It is essential to not only show what the mature plant looks like—for example, deadly nightshade is a vine—but also the part that most people might mistake as edible (nightshade's berries). Publishers also like to use images of plants that cause allergic reactions, such as poison ivy, poison oak, and poison sumac.

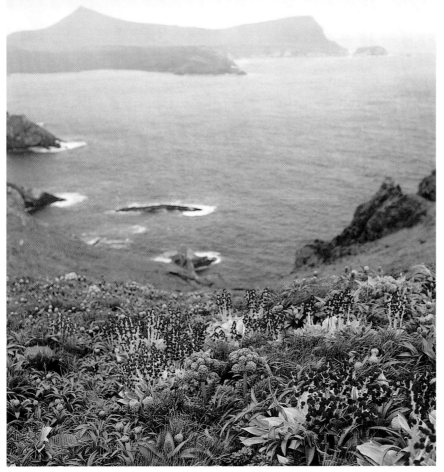

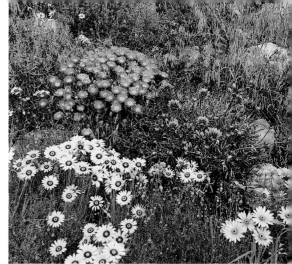

The intensity of South Africa's desert wildflower displays depends on spring rains, with September generally the best month to see the widest range of species. Ice plants—a type of daisy—are a particularly beautiful South African species, with iridescent flowers that close in the late afternoon and open again by mid-morning. On cloudy days, they can stay closed all day.

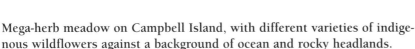

Mega-herb meadow on Campbell Island, with different varieties of indigenous wildflowers against a background of ocean and rocky headlands.

Some Favorite Wildflower Displays

Wildflower photo features can be sold to both garden and travel magazines. Indeed, I have sold more wildflower articles as travel stories than garden features. Here are some examples of my favorites. If you can spare the time and expense, the two most astonishing wildflower areas to visit are Namaqualand, South Africa, for its spring wildflower extravaganza of mostly African daisies, and New Zealand's Sub-Antarctic Islands where wildflowers called mega-herbs reach gigantic proportions in a cold, wet environment. Here's how I tackled both for publication.

The Wildflowers of Namaqualand

I have been invited by the South African Tourism Office to photograph the incredible wildflower displays that occur in an area known as Namaqualand, north of Capetown, twice. These have been used in numerous travel articles and calendars, including *Family Circle's Easy Gardening* (Spring 1999). The wildflower extravaganza is all the more remarkable because it occurs in a semi-desert region following a brief period of spring rains, and some years are better than others. During my visit, I was told I had chosen the first wildflower year in 20 years-and the best week!

The Namaqualand wildflower display occurs in early September, which is spring in South Africa, when an estimated 23,000 species carpet the plains and mountain valleys of a semi-desert region. Sometimes the display is all one species and color; other times hundreds of species may mingle their colors and forms. Although many of the wildflowers grow beside the road, the biggest concentrations can be found in the town of Clanwilliam, a small agricultural community along the Oliphants River. At the Roskop Nature Preserve were meadows sparkling with wild gladiolus, wild freesias, wild irises, all kinds of daisies, and curious "ice-plants" with petals that shimmer like satin.

South Africa's most spectacular wild-flower display can be found in a preserve near the village of Clanwilliam, with sheets of African daisies growing beside a beautiful blue reservoir. The combination of orange daisies and blue water is dramatic.

The most spectacular wildflower display I have witnessed other than New Zealand's Sub-Antarctic islands, is in South Africa, northwest of Capetown. The Biedouw Valley abounds in wildflower species. This profusion of wildflowers in an arid environment, against a spectacular backdrop of mountains, provides a strong sense of place.

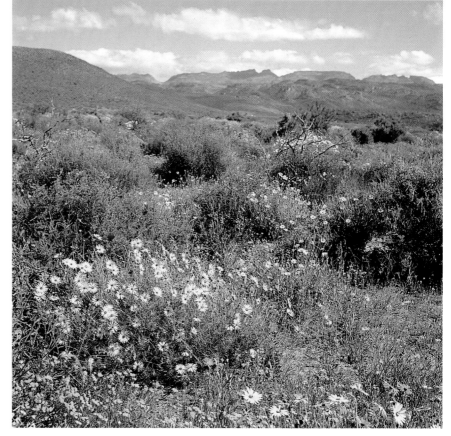

Campbell Island, in the Sub-Antarctic, is the last lost world, and a haven for mega-herbs and mega-beasts like elephant seals and royal albatross. To emphasize the size of wildflowers, and to provide a sense of the cold, wet conditions in which they survive, this picture shows me in swirling mist, dressed like Scott of the Antarctic.

Like a grass fire, a variety of sorrel, with crimson flowers, colonizes a slope at the edge of a windswept forest on Enderby Island, among New Zealand's Sub-Antarctic Islands.

During a diversion into the nearby Biedouw Valley, I discovered farms with signs marked *blumen* (flowers) pointing across private land to areas off the beaten track, where wildflowers could be photographed against a backdrop of spectacular mountains and between the wheel ruts of jeep tracks.

On a second visit for the South African Tourism Office a month later, I went to Capetown and was able to photograph another remarkable family of wildflowers in the wild. The amazing protea grow among alpine meadows along the more hospitable eastern coast, watered mostly by coastal fogs. Proteas are flowering shrubs that look like alien life forms. They have domed flowers, often with powdery white centers that appear to be composed of bird's feathers.

Wild Gardens of the Sub-Antarctic

From the hot, dry deserts of South Africa to the storm-thrashed islands of the Sub-Antarctic is perhaps the biggest jump one can make when photographing flowers. I would be hard pressed to say which was more spectacular, although probably the Sub-Antarctic would win. The desert wildflowers of Namaqualand are well-known, but few people were aware of the Sub-Antarctic's remarkable wildflower displays until I discovered them on a botanical expedition and published a travel feature in the March 1998 issue of *Architectural Digest*. This was followed by an article with a horticultural slant in the May issue of the *Journal of the Royal Horticultural Society*, Great Britain.

The Sub-Antarctic wildflower display occurs in January (their summertime) on two main island groups: the Aucklands and Campbell Island. I was invited to participate in a New Zealand expedition organized by Heritage Expeditions to investigate the regeneration of the wildflowers since foraging animals, mainly sheep and goats, had been removed from the islands a few years earlier. What we discovered was a renewal beyond anyone's expectations, but we were confronted with incredible obstacles, including heavy seas, stinging rain, fierce winds that could knock us off our feet, and heavy mists, plus ferocious mating sea lions and elephant seals that would often bar our path.

To show the mega-herbs at their best, I sought a number of special photo opportunities: dense colonies of as many varieties in close proximity to each other as possible to indicate the extent of regeneration; wildlife, especially nesting albatross and elephant seals, living among them; coastal cliffs crowded with flowers to show the influence of a marine environment; mist and rain to give a sense of cold conditions, and a striking image to give a sense of scale to the largest specimens.

By the end of the last day, I was still not sure I had a good image giving a true sense of "gigantism," until I asked a colleague, Dr. David Given, to take a picture of me among an enormous clump of Campbell Island carrot (*Anisotome latifolia*) that had flowers resembling heads of giant broccoli. I could have asked David to pose, but he was dressed inappropriately, swathed in sweaters and with a jaunty Australian sheepherder's hat that was a little too comical and out of context, whereas I looked like Scott of the Antarctic, with a Balaklava helmet that exposed only my eyes, a pair of goggles resting on my forehead, waterproof boots, and a warm, waterproof jacket.

The picture David took was perfect: The mist swirling around, the huge flowers in muted light, and me in proper Sub-Antarctic attire, all combined to provide a sense of scale and an accurate portrayal of the near-freezing conditions.

California and Texas Wildflowers

The wildflower displays of Texas and California occur mostly in spring, and vary from year to year because profuse flowering depends on winter rains. One of my favorite areas in Texas is north of Houston around the town of Chappell Hill, which sponsors a Bluebonnet Festival every March, with a local information office offering maps showing where the best wildflower displays can be seen. In addition to sweeps of bluebonnets, there are vast expanses of pink evening primroses and orange Indian paintbrush, the three often mingling their colors to create a dazzling effect.

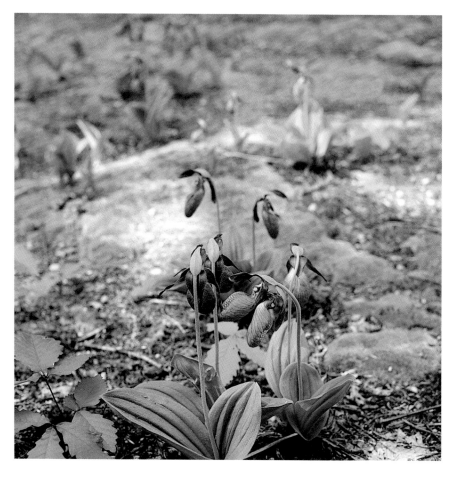

Ladyslipper orchids in the wild are now rare because of overbrowsing by deer. This impressive colony is protected by a deer fence.

Early morning, before the sun burns through the mist, often produces the best images, especially if some interesting landscape feature can be included to avoid a monotonous look. In particular, look for ranch fences, old barns, wildflowers in an orchard, among rocky outcroppings, and meandering streams.

California has many more wildflowers than Texas, and they tend to be in desert areas such as the Anza-Borrego Park east of San Diego, and Antelope Valley east of Los Angeles. Also, California has a spectacular coastline where images of wildflowers, surf and rocky promontories can be composed by choosing the right vantage point. Particularly impressive is the annual flowering of California poppies, often mixing their orange petal colors with blue sage for a stunning orange-blue color harmony. But always seek some appropriate accent to provide a sense of place, such as a stand of pincushion cactus in close proximity to suggest a desert environment, a mountain peak, or a stand of live oaks.

California poppies create great sweeps of orange along waysides and hillsides of California. Texas and California both enjoy spectacular wildflower displays in spring, similar to those of South Africa.

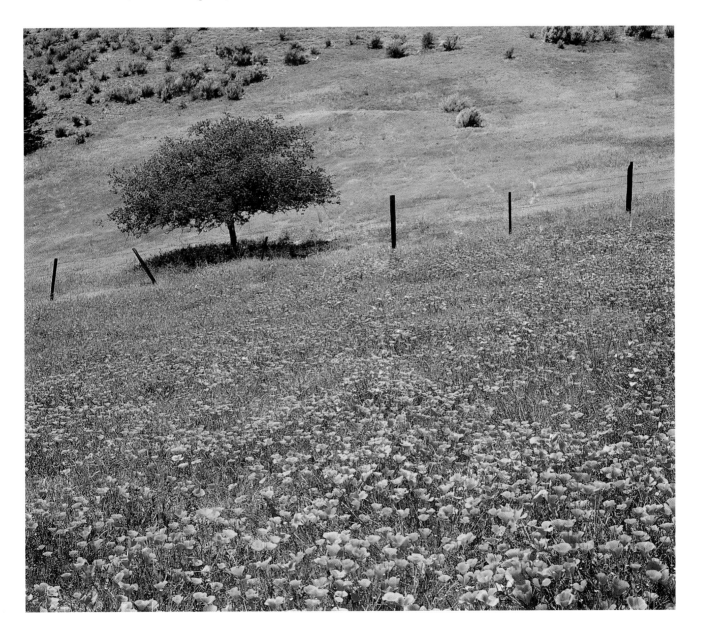

When I began shooting plant pictures, I concentrated on close-ups. For a time I became almost blind to the "big picture"— grand landscapes and scenic views. Even if your intent is to photograph a small garden with lots of design elements to make a good photo feature, it is still advisable to show what lies beyond the setting. If it is a coastal garden, photograph the coastal scenery, even if you cannot get the actual garden in view. If it is a rock garden hemmed in by mountains, be sure to show the mountains. If you cannot get what you want, such as a storm lashing the coast or a fresh fall of snow on the mountain tops, look for strong images during the early morning sunrise or late afternoon sunset when pronounced shadow patterns can augment the dramatic lighting.

There is a big difference between photographing small gardens and composing for grand landscapes and scenic views. In my experience, most home gardens are relatively intimate and romantic small spaces bordered by hedges, walls, or fences. Even for overall views, generally there is a definite

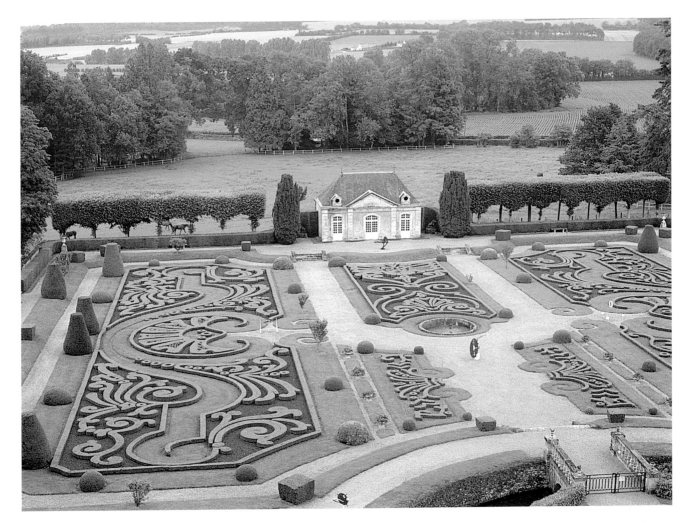

focal point such as a bench, bridge, or brilliant clump of flowers. Only in the most spacious gardens, the grand landscapes of Versailles Palace or the Vatican Gardens, do I find myself using the infinity setting on my camera lens. Similarly, in wilderness locations such as deserts and mountains, often there is a much bigger expanse to shoot. In my view, the bigger the panorama, the more challenging it is to photograph creatively because grand landscapes must express a mood and project a sense of season or local atmosphere. Examples are a meadow of wildflowers lit by a single shaft of sunlight breaking through a cloud cover, mist swirling around a lake covered in waterlilies, and a coastal garden in moonlight.

The best landscape photographers will hike for miles seeking secret canyons or unfamiliar vistas, only to find a scenic view that would look better in a certain light or different season and return when conditions are right. Luck sometimes presents a golden photo opportunity at a bend in the road after hiking hill country for hours!

But of course you should have the right equipment, which might include additional accessory lenses. The standard 35mm camera lens is 50mm. With its 47° angle of view, the lens "sees" about the same as the human eye. Lenses shorter than 50mm focal length are called wide-angle, and those longer are telephoto.

The Chateau Sassy in the Loire Valley, France, has a spectacular parterre garden. Without moving from a balcony of the chateau, I can create two distinctly different compositions by using different lenses. Above is Chateau Sassy's parterre garden using a wide-angle lens to show the immense scale of the hedge designs. The image on the next page is a different view of the garden shot with a telephoto lens.

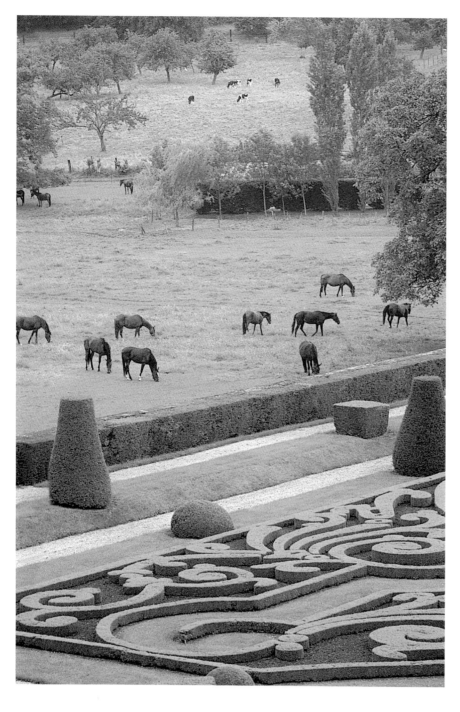

Using a telephoto lens, I wanted to contrast the formal parterre garden with thoroughbred horses in an adjacent wild meadow.

view with a standard lens simply by adjusting your viewpoint so subsequent images can be butted together.

A telephoto lens brings the subject closer, acting like a telescope. A 135mm lens is probably the most widely used by 35mm landscape photographers. It has an angle of view of only 18°, but enlarges images more than 2-1/2 times the view of a standard 50mm lens. In addition to bringing the subject closer, it visually compresses space so distant objects appear to be closer together.

Using these lenses can be fun, but be careful to avoid perspective distortion. For example, with a wide-angle lens, shooting from a very low angle with a tall tree in the background will cause the tree to appear as though it is leaning backward. Sometimes this is desirable for dramatic effect, but many photo editors consider this unnatural. Correct distortion by orienting the camera so the sides of the tall objects look parallel with the sides of the viewfinder. Sometimes, however, you can't achieve this correction, so another solution might be an even more specialized perspective control, or shift, lens, widely used by architectural photographers when photographing tall buildings.

A wide-angle lens, such as a 35mm with a 63° angle of view, is excellent for including elements beyond the garden. The viewer can then gain an appreciation of the setting because beautiful gardens often are located in stimulating surroundings.

In addition to traditional wide-angles, there are cameras and lenses that create a panoramic image three times wider than that made with a normal lens. There are even fish-eye lenses that cover a 360° sweep. In my experience, they are not needed because you can create a panoramic

The ruined arch of a monastery at Tresco dates to the 16th century. Located at the heart of the garden, I found it good to use as a dominant focal point and tried to include it in as many compositions as possible.

A big problem when shooting landscapes is atmospheric haze and glare. It is most pronounced at high altitudes and along the coast. Haze normally appears as a blue "fog" obscuring a distant view. When looking at a scene, we usually are not aware of the problem, but on film its effects are plainly evident, with distant details blocked out or the picture disappointingly dark. When shooting color film, use a haze filter or an ultraviolet (UV) filter to overcome the problem. Both types are clear and do not distort color. Many photographers mount one of these filters on the front of each camera lens all the time to protect it from scratches, dust, and fingerprints.

Favorite Grand Landscape Features

Over the years, I have had several assignments that involved shooting "the big picture." Here are some of my favorite grand landscapes or scenic views.

• **Tresco Abbey Gardens:** Often I am asked to name my favorite garden or favorite travel destination. They both happen to be the same place: Tresco Abbey Gardens on Tresco Island in the Isles of Scilly, located about 25 miles west of Lands End, England. It is the only garden I know with a helipad, because helicopter from the mainland port of Penzance is the quickest way to get there.

The island itself is only three miles long by a mile wide, warmed by the South Atlantic current that sweeps up from the Canary Islands off the coast of Africa. This keeps the island frost free and produces a stable maritime

When photographing coastal gardens like Tresco, it is essential to show images with plants and coastline to provide viewers with a true sense of "place." This colony of amaryllis was photographed at the edge of a rocky beach, against a muted sunset.

climate ideal for growing a large assortment of plants, many of which were collected from South Africa, Mexico, and New Zealand. My first photo feature about the gardens appeared in the June 1977 *Architectural Digest*, then in *Horticulture*, earning a Best Magazine Article award from the Garden Writers Association of America.

Built within an old stone quarry, the gardens are beautiful beyond description—but the coastal scenery is equally compelling. When photographing the gardens, it is vital to include some of that coastal scenery. *Architectural Digest's* editor told me that the most appealing picture in the entire piece was of the old manor house overlooking a sandy beach, with a saltwater pond in the foreground. A swirl of white clouds above the castle-like residence seemed to connect with the curve of the beach, giving the image an ethereal quality.

Also important is to show some of the extraordinary plants that grow within the gardens: tree ferns from Australia; king proteas from the Cape of Good Hope; giant succulents called puyas, with huge jade-green flower spikes, from the mountains of Chile, and fiery rata trees from the coast of New Zealand.

The work of late Roberto Burle Marx, landscape architect, has had an important influence in landscape architecture. Working from his home near Rio de Janeiro, Brazil, he accomplished distinctive garden designs on a massive scale, using plants in great sweeps of color to carpet the landscape. Perhaps his most ambitious commission was the Monteiro Estate at Petropolis, where he landscaped an entire valley floor. To avoid a sterile, flat panorama, I photographed the house and main part of the garden through a gap on a wooded slope, where a stream descends into the valley.

The owner of Tresco Abbey Gardens, Robert Dorrian-Smith, was pleased with my work and invited me back to take a series of publicity pictures to promote tourism to the island. He placed a launch at my disposal, with a captain to steer through a labyrinth of rocky islets, so I could take landscapes from that angle. Soon after, the island was hit by a series of savage storms that took about 20 years to recover from.

• **The Gardens of Roberto Burle Marx:** When the great Brazilian landscape architect, Roberto Burle Marx, passed away, he willed his garden to the state. Shortly after that, I was invited by the Brazilian Tourism Office to not only photograph his garden but also the ambitious gardens of several private clients, including the vast Monteiro Estate in Petropolis, just north of Rio de Janeiro. For the Monteiro family, Marx was able to landscape an entire valley floor, nestled among majestic Sugarload Mountains. Marx used huge beds of colorful plants to "paint" the landscape of this tropical garden. He filled the property with water features, including several lakes and meandering streams with naturalistic swimming holes.

The views are breathtaking, especially from the house. But my favorite picture was taken looking along a watercourse that is stepped to descend a hill toward the house, with tree branches framing the house in the distance.

Marx's own garden was filled with examples of his art, and many parts of the garden were designed to display some of it. The most famous of his designs is a wall, resembling an Inca ruin, on which he grew bromeliads. Other parts of the property were landscaped to resemble an Amazon rain forest, with banana trees and palms strategically planted to provide foliage contrasts, and lower limbs pruned to provide clear views along ravines.

The most distinctive feature of Marx's own garden, which is now open to the public, is a wall representing an Inca ruin. With palms positioned so their shadows play across the face of the wall as the sun moves across the sky, the wall acts like a movie screen.

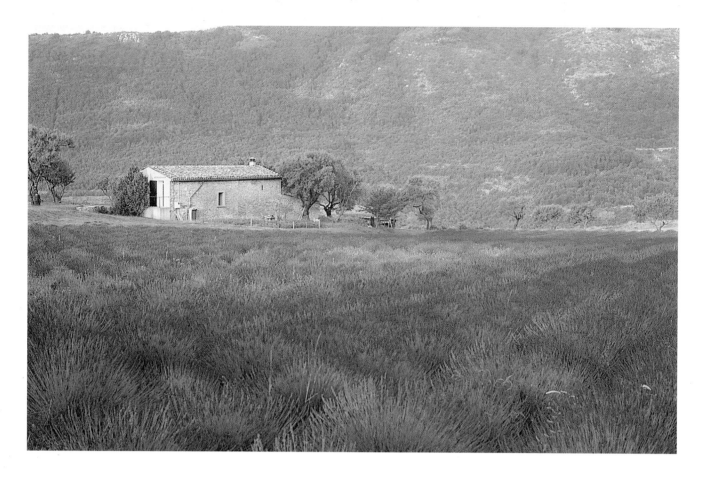

I traveled to Provençe, seeking lavender fields where the fragrant herb is grown for perfumed oils. The blue of lavender is greatly affected by the quality of light shot at different times of the day. The photo above shows the Cauvin Farm, near the village of La Pardu, in early morning light. The image on the opposite page shows the lavender field at noon. This image of the lavender farm shows a farm track leading the eye to a farmhouse. The composition is also strengthened by framing the field with the olive tree trunks. Both images have an artistic quality and have sold successfully as prints for framing.

• **The Gardens & Landscapes of Provençe:** I have visited Provençe on assignment several times for books involving Impressionist painters—first to photograph Renoir's Garden near Nice; also Cezanne's Garden at Aix-en-Provençe; and the Asylum at St. Remy where Vincent Van Gogh was institutionalized during a prolific painting period. Many of these images appeared in my award-winning book, *The Impressionist Garden*, and *Renoir's Garden.*

Of course, the district of Provençe is a photographer's dream, not only because of its scenic beauty, but also its historic architecture, quaint villages, and old, weatherworn farms. For my purpose, I wanted images that had impressed the Impressionist painters, particularly scenes of poppy fields, old trees, and lavender grown for its aromatic oil.

My favorite images of Provençe are of Renoir's garden with its ancient olive trees, and a small lavender farm situated beside the main road at La Pardu. This road is midway through the Gorge of Verdun, where it first travels through the gorge and then rises above it, dipping back into the gorge beyond the village.

When I pulled up to a farm stand where the farmer was selling lavender products to passing tourists, I noticed he refused a tourist permission to photograph the lavender field inside his fence. After the tourist departed, I realized he had failed to purchase any of the farmer's products, probably the cause for the uncooperative attitude.

(Opposite page) On an assignment to photograph the flower fields of the Lompoc Valley, California, I could hardly believe my luck when I drove up a dusty gravel track and crested a mountain pass. I was confronted with this scene: an entire valley floor, growing colorful strips of annuals for seed production, from mountainside to mountainside, in what seems to me to be the world's biggest work of art.

I kept my camera equipment inside the car until I had purchased $100 worth of his lavender soaps, lavender honey, potpourris, sachets, body lotion, and perfume. He was delighted, and when I casually asked if I could walk across his fields to take a picture, he not only agreed without hesitation, he suggested some good camera angles—and even pointed to a rough track winding farther up the mountain where he knew of a ruined castle surrounded by wild lavender! It was a glorious day, photographing the cultivated lavender fields, exploring the track up to the wild area, and staying overnight in a tiny guest cottage overlooking the spectacular valley and its sea of lavender.

To capture the magic of Renoir's garden, it was necessary to show not only overall views of the garden in all seasons—especially the magnificent old olive trees and carefree wildflower meadow—but also the house interior with its studio and large windows offering commanding views of the garden. I was particularly struck by a display of Renoir's painting paraphernalia, and gained permission from the curators to move his easel and paints outdoors to a place in the garden where an old archive photograph showed Renoir painting.

• **Fabulous Flower Fields:** Flowers can look exceptional in a garden setting, but they excel when photographed as a mass of color in production fields grown for bulb or seed production. The main area for bulb production is Holland, near Lisse, although there are some substantial farms in Oregon and Washington State. For flower fields, nothing can compete with the Lompoc area of California, located between Los Angeles and San Francisco, where there are production fields with hundreds of acres of flowers grown for seed. In some places, the effect of all this color turns an entire valley floor into a gigantic work of art.

The biggest problem with photographing flower fields is achieving sufficient elevation so the lines of flowers do not appear as a thin band across the middle of the frame. Even a tall stepladder may be an inadequate platform, so look around for a tree to climb, or the upstairs window of a farmhouse. I have even stood on top of tour buses parked beside the road to get a good "aerial" view of flower fields.

When shooting in California, sometimes it is possible to include mountains, or a large barn so the composition is not just a monotonous expanse of blooms. Because Holland is largely flat, it may be difficult to find an

The biggest problem with photographing flower fields is achieving sufficient elevation so the lines of flowers do not appear as a thin band across the middle of the frame.

interesting background. However, they do have beautiful farmhouses—sometimes thatched—and also windmills that can help provide a suitable sense of "place." Also seek special atmospheric conditions, such as ground mist and blustery skies.

• **Desert Landscapes:** The Sonoran Desert, which extends across parts of Arizona and California into Mexico, is a spectacular wilderness area full of sensational picture possibilities—but the enemy of exquisite pictures in the desert is harsh sunlight. Fortunately, the desert has many moods, particularly in the early morning and late afternoon, and winter, when some extraordinary qualities of light can produce exquisite images. Of special interest are the many sculptural forms that succulents and desert cacti can offer in protected areas, such as the Saguaro National Forest near Tucson. Here, colonies of gigantic saguaro cactus cover hundreds of miles in the company of desert wildflowers and other cacti such as the whip-like ocotillo and the spiny teddy-bear cactus. In nearby Joshua National Park, near Palm Springs, a native yucca produces plumes of white flowers on tall, spiky plants that are often twisted into bizarre forms among rock formations, and the writhing limbs of mesquite trees.

Many of the desert cacti offer colorful blooms during spring and early summer. Even out of bloom, it's often just a case of finding a special lighting situation to make stunning silhouettes from the desert plant life. Examples are a purple desert sunset, or backlighting to make the golden spines of a teddy bear cactus appear soft and fuzzy.

(Opposite page) For this spectacular view of a Dutch tulip field, I was able to stand on the luggage rack of a rental car to better emphasize the strong lines of perspective.

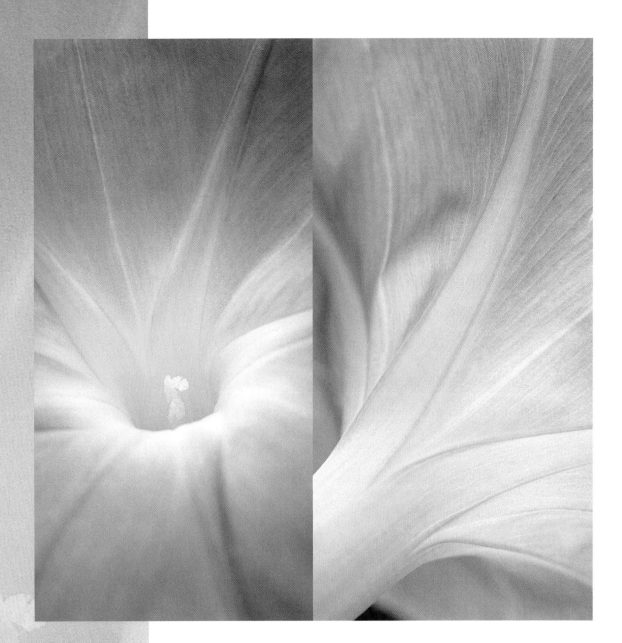

How well I remember reviewing the results of a photography contest judged by a picture editor from a national magazine at famous Longwood Gardens. The top prizes all went to close-up pictures. Among ten awards, nine were for close-ups, with only one for a general landscape scene. When I am required to judge photography contests, the ratio is different because I believe that a stunning landscape scene is far more difficult to capture than a beautiful close-up. Although close-ups can be dramatic because they present a viewpoint we don't normally see, moderate close-ups are easy to take, especially with a 35mm SLR camera and diopter close-up lenses, extension tubes, macro lenses, or a combination of all three. Closer magnification requires additional extension tubes or a bellows.

Flowers, fruit, and leaves offer unlimited scope as close-up subjects. There seems to be no end to the bizarre shapes, exciting textures, and brilliant colors that can be captured photographically in clear close-ups. Here are some of the accessories to help you achieve these results:

(Opposite page) Two close-up views of morning glory "Heavenly Blue," looking down the throat of the flower, and looking up from the underside of the petals.

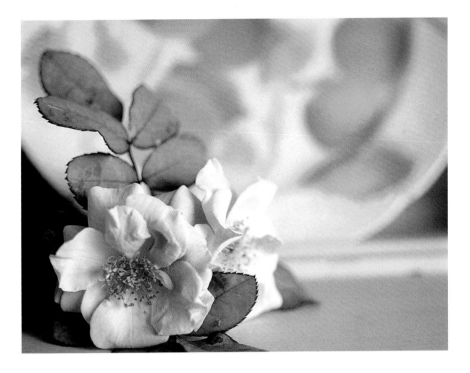

• **Diopter Close-Up Lenses:** The simplest, most inexpensive way to get closer to a subject than the standard lens allows is to add a screw-on "diopter" close-up lens. This lightweight accessory resembles a filter and magnifies the image using the camera's standard lens. Most come in sets of three (number 1, 2, and 3) with the larger numbers taking you progressively closer to the subject for greater magnification. These screw onto the front of the camera lens just like a filter, and can be stacked to achieve a desired magnification. For example, stacking a #2 and a #3 will take you closer than using a #3 alone. When stacking them, you must place the strongest one (highest number) closest to the camera lens. You cannot use close-up accessories with wide-angle lenses.

I have found that most of my flower close-ups were photographed with a #3. And because they are so lightweight, they are a good alternative to carrying a special macro close-up lens.

• **Extension Tubes:** The next easiest way to take close-ups is with an extension tube, which has no glass lens. It is simply a cylinder that mounts on the camera between the lens and the body. This provides a quick way to get dramatic close-ups of insects such as butterflies and bumble bees pollinating flowers.

• **Macro Close-Up Lenses:** Magnifications of 1/10- to 1/2-life-size are considered moderate close-ups and are easy to create with a macro lens with or without additional diopter lenses and extension tubes. Most manufacturers include macro lenses in a range of magnifications as part of their specialty interchangeable lens line. Some can be used as a standard lens, allowing you to shoot landscapes and then focus down to half life-size in one continuous motion. Macro lenses can also be used in combination with an extension tube to increase magnification beyond the lens' normal range.

Close-ups of flowers can be sterile without showing something pertinent in the background. Here, a single blossom of "Autumn Damask" rose shows how its color has influenced the pattern of a plate in Renoir's home, designed by Renoir's youngest son.

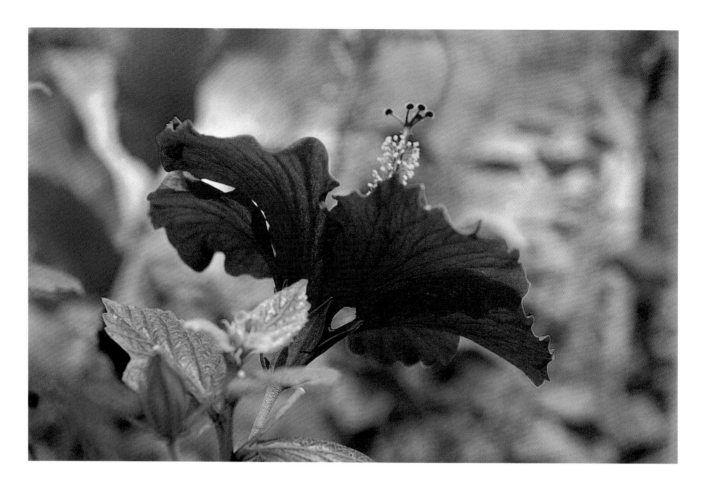

Artist Claude Monet preferred to plant single flowers over double forms because singles, like this hibiscus, generally have translucent petals. When backlit, the petals shine like lanterns, producing a shimmering quality in the garden.

• **Bellows:** For greater magnifications than a macro lens and an extension tube will provide, bellows are the answer. However, it is a big step to move from simple diopters and extension tubes to a bellows system. Bellows allow for the highest magnification, but must be used with cameras that offer OTF (off-the-film) metering; otherwise, the camera's metering system may not accurately measure the light level.

Bellows are similar to an extension tube, but offer greater flexibility. The entire apparatus, which is quite bulky for field trips, fits between the camera lens and the camera body, with adjustable extension provided along a metal track. Use a sturdy tripod and a cable release to keep it rock steady. With a bellows, it is possible to photograph tiny plant parts, such as pollen grains and the facial features of insects, in clear detail.

Depth-of-Field

Normally, when working in the close-up and macro realm, it is essential to use fine-grain, slow-speed film in combination with as small an aperture (higher f-number) as possible. The larger the aperture (lower f-number), the less depth-of-field (zone of acceptable focus) and the more difficult it is to produce a sharp image. I prefer to shoot close-ups at f/11 or higher. This requires plenty of light, and sometimes an electronic flash or a ring light. On cloudy days, essentials include a tripod so you can shoot at slow shutter speeds, and a cable release to avoid touching, or shaking, the camera.

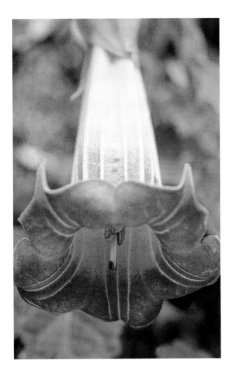

A high overcast sky has helped capture the extraordinary orange coloration of this angel's trumpet, a native of South America. Tropical flowers generally present the most exotic flower forms.

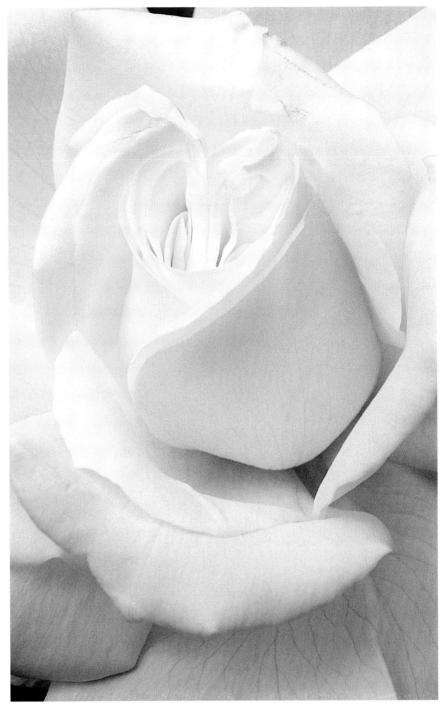

Even with the simplest close-up lenses, correct exposure is not always easy to determine, especially when you have pale petals against a dark background or dark petals against a light background. For consistently accurate close-up metering, use a camera with a spot-metering mode and try to create a diffused lighting quality by shading the subject with a white umbrella or a white fabric canopy. Few close-ups look good taken in harsh sunlight or with a "busy" background where in-focus, extraneous elements detract from the main subject.

The swirling petals of rose, "White Masterpiece," were captured using a diopter close-up lens.

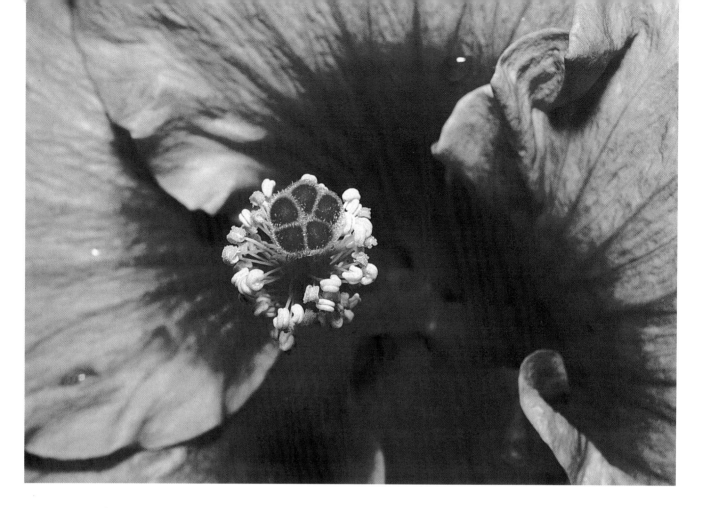

The intimate parts of an hibiscus flower are my primary focus in a close-up that relies on dramatic color for impact. I used an accessory electronic flash to provide sufficient light for sharp focus and adequate depth of field.

Artificial Lighting

There are three types of artificial lighting: electronic flash, floodlight, and ringlight.

• The most difficult artificial lighting to control is electronic flash because you cannot see its effect on the subject until the film is developed. An alternative is to take "preview" shots using Polaroid film in an interchangeable film back. Flash may cause harsh shadows, hot spots, and bright reflections on shiny surfaces. It is a poor choice for close-up work unless you are using a camera with OTF metering and a system-dedicated flash unit. With OTF metering, diffused electronic flash can be the most convenient method of taking close-ups.

• A floodlight is easier to control because it can be moved easily and you can evaluate accurately the lighting effect before making exposures. Professionals use floodlights for close-up work more than any other artificial lighting. However, be aware that floodlights can get extremely hot, causing flowers to wilt.

• A ringlight is a circular flashtube that mounts on the front of the camera lens, surrounding it with light. The ringlight illuminates a small, close subject with even, shadowless light. It is excellent for close-ups of flowers (particularly wildflowers), and other plant parts that have non-reflective surfaces. However, if a subject such as a tomato has a shiny surface, reflection problems may result; consider a ringlight featuring a polarizing filter to diffuse the glare.

(Right) "Irish Eyes" gloriosa daisy is a type of black-eyed Susan, but its eye is green. This unique and appealing feature is emphasized by shooting a single flower head-on, with the green eye at the center.

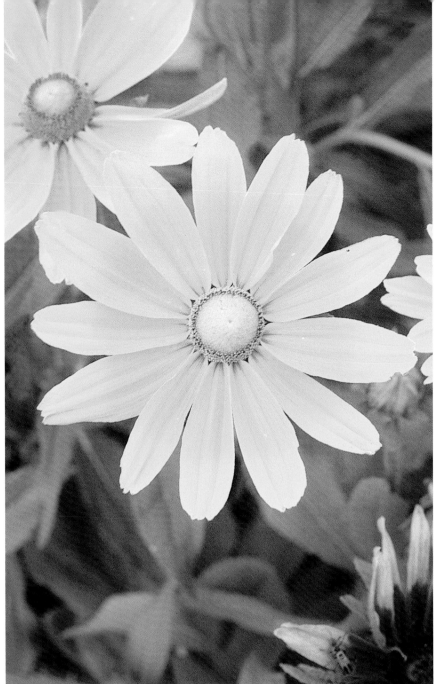

The most difficult artificial lighting to control is electronic flash because you cannot see its effect on the subject until the film is developed.

Bromeliads are a large family of plants that grow mostly in the crotches of trees in the rain forests of South and Central America. Generally they have swept-back, strap-like leaves and exotic flowers. Here are two varieties: a variety of aechmaea (top left) and a tillandsia (bottom left). For each, I used diopter close-up rings that screw onto the lens like a filter, to get closer into the subject.

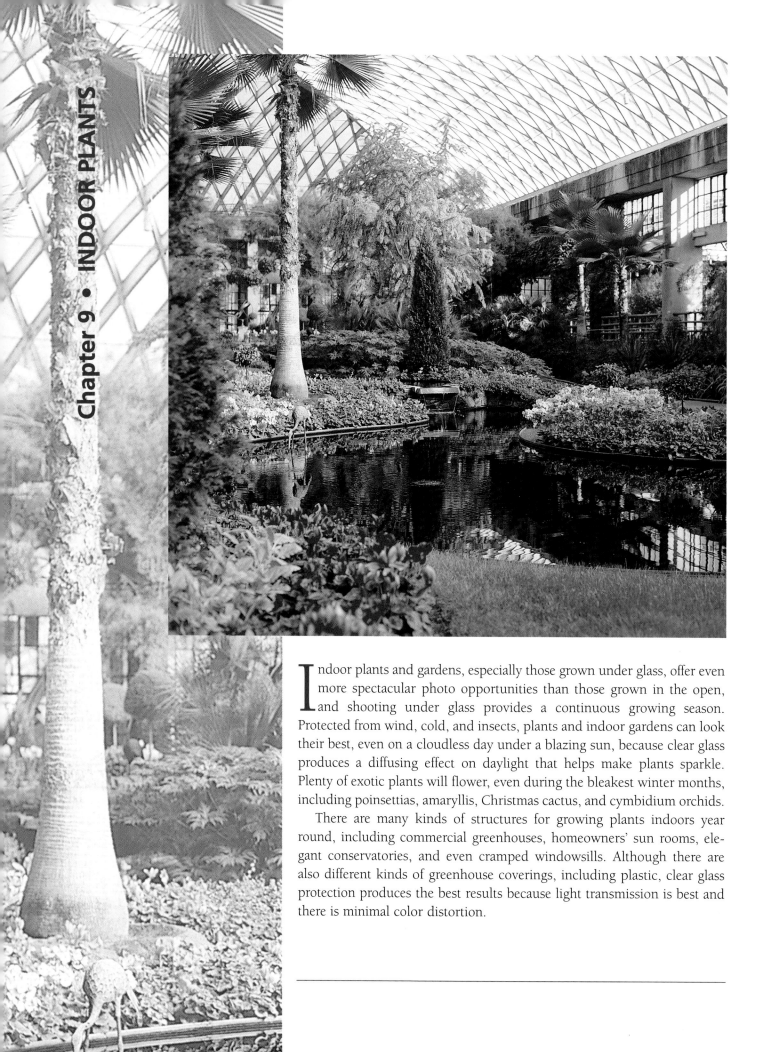

Indoor plants and gardens, especially those grown under glass, offer even more spectacular photo opportunities than those grown in the open, and shooting under glass provides a continuous growing season. Protected from wind, cold, and insects, plants and indoor gardens can look their best, even on a cloudless day under a blazing sun, because clear glass produces a diffusing effect on daylight that helps make plants sparkle. Plenty of exotic plants will flower, even during the bleakest winter months, including poinsettias, amaryllis, Christmas cactus, and cymbidium orchids.

There are many kinds of structures for growing plants indoors year round, including commercial greenhouses, homeowners' sun rooms, elegant conservatories, and even cramped windowsills. Although there are also different kinds of greenhouse coverings, including plastic, clear glass protection produces the best results because light transmission is best and there is minimal color distortion.

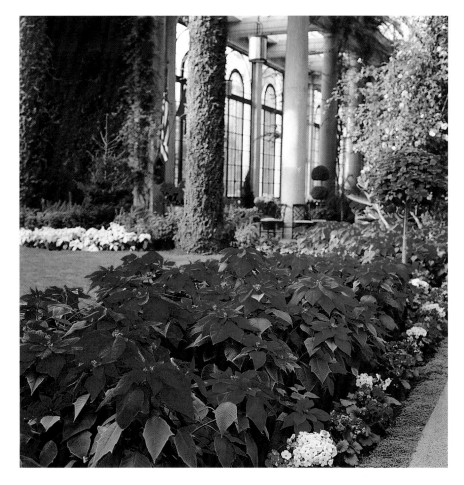

(Opposite page) A winter display in the main conservatory at Longwood Gardens, Pennsylvania, features yellow Australian wattles and pink cyclamen. Because dramatic overall views like this are difficult to light artificially, I chose a time of day when natural daylight produced the least amount of contrast between light and shadow areas.

Photographing Under Glass

Not only does shooting through glass rather than plastic produce better photographs, it grows the healthiest plants indoors. That's because clear glass transmits light best. In the world of indoor gardening, as little as 1% improved light can translate into 100% improved plant performance. Also, plastic and other glass substitutes tend to discolor soon after installation, causing serious color distortions on film, in the form of a yellow cast, that makes white flowers look creamy and green leaves look yellow. Even glass can produce yellow tones in the morning and blue tones in the afternoon; the purest colors are found at mid-day.

An important accessory for photographing under glass is a reflector because light in a greenhouse or a conservatory can be directional, especially in lean-to structures where a brick wall can face a glaring sheet of glass, causing deep shadows. With a reflector, you can manipulate the light so it more evenly illuminates the subject, or brightens the background.

Close-ups of individual plant specimens offer the greatest opportunities for creative photography, especially plants used in pots, windowbox planters or hanging baskets, but it is also possible to find complete gardens under glass. Longwood Gardens, near Philadelphia, Pennsylvania, has five acres under glass, incorporating palm trees, water features, and lawns.

Longwood Gardens has nearly five acres of indoor gardens under glass. The Christmas period draws huge crowds to view its stunning poinsettia display. Shooting this border on an angle helps the composition.

Most editors seeking house plant photographs want to see the plant in a pot. This magnificent maidenhair fern was part of an imaginative display showing interior design ideas at the Elleslie Flower Show, New Zealand. Note how the blue vase echoes other background decorative elements.

Advantages of a Home Conservatory: I have found a glass structure to be so important for photographing plants that I added a Victorian-style conservatory to my home. It actually serves a dual purpose: as an indoor studio with natural light, and as a bright, comfortable breakfast room adjoining the kitchen. The attractive structure also added value to my home. Now, no matter what the weather, I can be shooting plant portraits or making special displays with indoor plants year-round.

• **Specimen Pictures:** There is a steady demand for house plants in stimulating surroundings such as a home setting. This can be a simple foliage plant such as a Boston fern in a hanging basket, placed in a window niche, or a more exotic flowering plant such as a gerbera daisy placed on a table or pedestal.

Before photographing house plants as specimens, carefully examine the plants for blemishes because the slightest imperfections can make a photo unsalable. Check leaves for signs of sunburn or general decline, such as browned leaf tips, and flowers for a lackluster appearance. Remove any leaves or flowers that are not perfect and, because a symmetrical shape is often important in such photos, fill in any gaps with fresh leaves or flowers.

After inspecting the subject and cleaning it up, carefully evaluate the background. If there are ugly greenhouse struts or plumbing parts showing, consider covering them over with other plants or an artificial background. Often plants in a greenhouse are clustered together and need to be separated so each one's form is clearly evident. It may also be better to move background plants farther back so they don't compete for attention, or shoot at a smaller f-stop so the background is sufficiently out of focus.

Cissus rhombifolia, a trailing vine photographed in a decorative pot. Other potted plants were chosen as background elements deliberately to show off its attractive green leaves.

• **Pots:** Many an indoor plant portrait has been ruined by an inappropriate pot, especially a white plastic pot. When in doubt, use terra-cotta or a clean clay pot, which are the universal favorites with editors. When photographing hanging baskets or windowboxes, avoid any kind of plastic container. For baskets, the best is wire mesh, with a "nest" of sphagnum moss between the wire and the soil. For window boxes, wood or clay is preferred. However, use some imagination, such as ferns in an empty magnum bottle or daffodils in a leather boot. One of my most frequently published container pictures shows a collection of foliage plants growing in a defunct television set, with grow lights used to keep them healthy within the screen area.

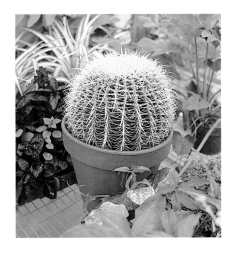

Images like this, of a barrel cactus in a clean terracotta clay pot, can be sold for both features on container gardening and house plants.

• **Collections:** Many amateur gardeners have greenhouses where they practice their hobby of growing a particular plant family. Seek these people out through your local horticultural society. Often you can locate treasures not found easily elsewhere, especially among passionate collectors of cacti, orchids, and begonias.

Failing a keen amateur collector, often you can find a specialist commercial grower who will allow you freedom to photograph plants. Unfortunately, commercial growers generally have their plants in regimented rows not conducive to good photography, but most growers will allow you to move plants to a section of the greenhouse where it's possible to make an appealing display. Otherwise, purchase plants to take home.

When photographing African violets at Tinari Greenhouses near Philadelphia for a garden magazine, I not only shot individual varieties in pots, but also made this tight arrangement all on one plane to show a range of colors.

...you don't have to be an expert to make beautiful floral arrangements...

• **Flower Arrangements:** Although flower arranging is an art form, you don't have to be an expert to make beautiful floral arrangements. A few stems of daffodils or sunflowers informally arranged for a publication's outdoor-living article, or tightly grouped for a seed-packet illustration can look exquisite in an indoor or outdoor setting.

For lavish arrangements, it's best to seek the help of a professional who understands rules of balance, location, color harmony, and texture. I used a professional to create a series of 25 arrangements for a book, *Impressionist Bouquets*, even though I was using famous Impressionist paintings for inspiration. Some of the arrangements were complex, the plant material needed "conditioning" to keep it looking fresh, and it sometimes required days of scouting to find the right vase or the best location. For a particularly beautiful photograph of a painting by the early American Impressionist, Childe Hassam, entitled "Room of Flowers" (1894), we decorated an entire room to match the decor of the room in the painting.

Of course, there are times when you will find stimulating floral arrangements ready-made, displayed in the perfect location, such as herbal wreaths on barn doors at herb farms, in the historical homes of Colonial Williamsburg, and the foyers of Southern Plantation homes. Avoid flower arrangements that are "posed" against plain backgrounds, or displayed like flower-show entries in recessed niches. They may be fine for judges to evaluate, but as photo opportunities they are too sterile.

Most Popular Houseplant Photos
These houseplants are most requested by publishers (seasonal periods are in parenthesis).

Indoor Flowering Plants
African Violets (year-round)
Amaryllis (winter-spring)
Azalea (winter-spring)
Begonias (year-round)
Cactus (spring)
Calamondin Orange (year-round)
Flamingo Flower (year round)
Fuchsia (spring-summer)
Gloxinia (spring)
Hibiscus (year-round)
Orchids (year-round)
Poinsettia (winter)

Indoor Foliage Plants
Bromeliads (year-round)
Caladiums (spring-summer)
Coleus (year-round)
Crotons (year-round)
Dieffenbachia (year-round)
Dracaena (year-round)
Ferns (year-round)
Ficus (year-round)
Jade plant and other succulents (year-round)
Parlor palms (year-round)
Philodendron (year-round)
Spider plants (year-round)

An indoor fernery at the Morris Arboretum, Pennsylvania. Natural light on a cloudy day eliminated harsh shadows from roof struts that often mar pictures of ferneries.

Indoor Lighting

You will encounter three basic lighting situations when shooting indoors: adequate natural lighting, as in greenhouses and conservatories; uneven natural lighting such as directional light streaming through a window; and inadequate natural lighting, as in a dimly lit room. You can use daylight or tungsten film indoors, depending on the type of light: daylight film when relying on natural light and with electronic flash, which simulates daylight; tungsten film for incandescent lighting such as floodlights, unless the floods are fitted with color-corrected lamps that simulate daylight.

• **Natural Lighting:** It's surprising how versatile and creative you can be using only natural light, especially when a "mood" is desirable, such as a shaft of light spotlighting a potted plant in an historic home. Where a more evenly lit subject is needed, a reflector can be used to bounce daylight into shadowy areas.

• **Artificial Lighting:** When shooting indoors, you often encounter uneven lighting that reflectors cannot correct, or inadequate natural daylight. In such situations, it is necessary to use some form of artificial lighting, such as flash or floodlights or a combination.

Flash: You can use flash when the location is not adequately illuminated, or to modify existing light for a technically better picture. This can involve a manual system using flashbulbs, which are discarded after one use, or reusable electronic flash units that are prevalent today. Some electronic flashes read light reflected from the subject and turn the flash off when enough reflected light has been measured for correct exposure. You set film speed on a calculator dial, which then indicates aperture size for a range of distances. As long as you work within that range, the flash controls the amount of light automatically. This type of flash is called "conventional" because camera-regulated automatic flash offers additional advantages.

A camera-regulated automatic flash works directly with the camera and takes advantage of "off-the-film" (OTF) technology. Requiring a dedicated flash unit designed for a specific camera brand and model, the flash/camera combination measures the amount of light and turns the flash off when the light at the surface of the film is sufficient for correct exposure. Accuracy is impressive, even when shooting through a bellows or extension tube. OTF technology is a feature of many of today's cameras.

Most cameras have a "hot shoe" for mounting an accessory flash unit, usually positioned on the body above the lens. In this position, the flash floods the subject head-on with bright light, creating harsh shadows behind petals and leaves. An optional snap-on diffuser mounted on the flash (or use a white handkerchief) will soften shadows.

Another way to prevent ugly background shadows is to position the subject far enough away from the background so no shadow will show on it. Also, using bounce lighting, aiming the flash at a reflective surface (preferably white) such as a ceiling creates softer indirect lighting by diffusing the light reaching the subject. Two or more flash units will soften shadows as well: one as the main light source, and the other(s) to eliminate background shadows. However, not all camera models allow use of multiple flash units.

Floodlights: An alternative to flash is the floodlight. When photographing a flower or a compact plant growing against a dark background, the simplest setup is a single floodlight, directed toward the subject at an angle. This illuminates the plant while keeping the background in darkness, creating good contrast.

Floodlights allow continuous evaluation of the lighting effects. And just as with multiple flash, two floods are better because one can provide the main light while the other creates fill to eliminate harsh background shadows. Additional floodlights may be needed to illuminate some indoor scenes, such as in a large indoor garden or a display at an indoor flower show with plants placed in different areas. One example is a room filled with hanging baskets, table arrangements, and potted specimens in window recesses, where you might set up a main light, a fill light, several spotlights, an edge light, and even an overhead boom light.

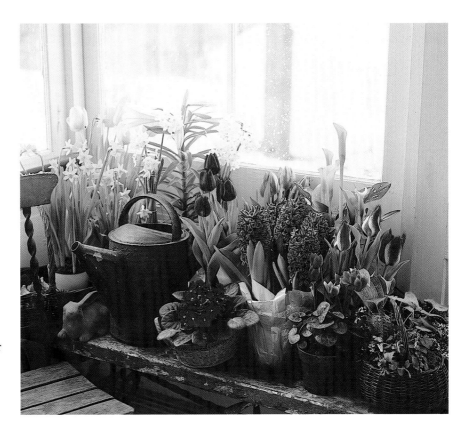

Many spring-flowering bulbs, such as tulips and hyacinths, are used for winter color indoors, so editors especially like to see snow through the window. This display is in a sunroom at Cedaridge Farm.

I used to think of people in plant pictures as intruders. Usually when I am photographing gardens I seek images without people because that's what most editors prefer. However, there are occasions when a person contributes something special to a scene. This typically is when I do a photo feature and want to show the owner enjoying the garden, usually for publication as a small "inset," but sometimes for larger presentation. Also, people are sometimes needed to provide a sense of scale or a romantic element in greeting card scenes (especially children, elderly couples, and young couples). More frequently, I use a person to demonstrate a step-by-step sequence, such as dividing perennials.

(Opposite page) Pronounced lines of perspective from a high elevation, and the presence of two plant breeders inspecting a crop of marigolds, help to produce a spectacular image of flower fields near Santa Paula, California, for an article in *Horticulture* about the American seed industry.

My son, Derek Jr., helps provide a sense of scale for a mammoth cabbage. This picture has been used extensively for seed packets and seed-catalog illustration.

Improving People Pictures

Here are some tips when photographing people:

• When shooting a person along with a giant vegetable such as a record-breaking pumpkin or a jumbo tomato, have the product in front for the most dramatic impression of size, and show the individual looking at the vegetable rather than at the camera.

• When using a model or a couple in a scene for a romantic touch, often it is better to show the people out of focus in the background. Also, try to color coordinate their clothes so the clothes are in harmony with the surroundings. For example, the Impressionist painter, Claude Monet, painted his stepdaughters wearing blue dresses in a garden with blue overtones, and a young woman wearing a yellow straw hat, beige dress, and orange wool sweater in a rose garden of matching colors. Always try to show a couple rather than a single person, even if one of them does not garden. People like to see companionship, especially in a beautiful garden!

Noel and Gordon Henschel are the owners of Stonepine Ranch, a resort hotel near Carmel, California. Set among spectacular mountain scenery with wildflower meadows, at one time Stonepine was a country retreat for the Crocker Bank family of San Francisco. When I photographed the property for publication, I needed a picture of the couple; instead of posing them on the grounds of the resort, I took them into a remote valley where wild bluebonnets were blooming, to provide a better sense of the serenity and tranquility of the estate.

• When using models for step-by-step photography, have them wear gloves if the chore involves work that can soil hands, like pruning or planting bulbs. With women, it is best if they wear jeans because these are not likely to go out of fashion as quickly as other forms of dress, such as a skirt or shorts.

• To avoid paying model fees use members of your family, especially your spouse and children. If using a model as the main focus of the image, get a release signed and even if no modeling fee is requested, pay $1.00 to make the contract binding.

• When shooting owners of gardens, avoid obviously posed situations. On one assignment, I discovered an owner, with his shirt off, planting irises. His muscular body bronzed by the sun like Picasso's, his thick white hair like Einstein's, he was a picture of health, vigor, and contentment. But when his wife saw me preparing to take a photograph, she called for her husband to come inside the house. He dropped his spade, grabbed his shirt, and disappeared, to emerge several minutes later dressed as though he were going to a cocktail party! His wife did not realize that the more spontaneous image of him working bare-chested was a much better picture for my purpose.

Kurt Bluemel is a nurseryman responsible for popularizing ornamental grasses in the United States. For a book on ornamental grasses, I posed him in his garden, framed by the arching leaf blades of miscanthus grass.

Children often are key elements of appealing images. Here is my youngest daughter, Vicki, in a field of perennial sunflowers at Cedaridge Farm. Choosing a high elevation and bleeding the sunflowers off all four corners of the frame helps produce a charming "people" picture.

Pumpkins are fun to photograph, but the giants usually need a person for a sense of scale. Because blue and orange are a good color combination, my wife Carolyn agreed to dress appropriately for this picture taken on an overcast day in a pumpkin patch.

(Opposite page) The late H. Thomas Hallowell created a replica of the historic maze at Hampton Court Palace, England, on his Deerfield estate near Philadelphia. Using a cherry picker to gain height, I took this picture of him for a feature about his garden in *Architectural Digest*. I chose a cloudy day to avoid harsh shadows falling across the maze, so its boxwood design could be seen more clearly.

My oldest daughter, Tina, posed for this picture while she gathered flowers in a colorful garden of annuals to illustrate a book on cutting gardens. When a romantic note is needed, models look good in white.

Step-by-Step Photography

One of my most profitable assignments was for a series of books for *Better Homes & Gardens* on a variety of popular subjects, including annuals, perennials, herbs, and even ornamental grasses. How-to or step-by-step sequences normally were done by artists, but for this series of books the editors demanded photography. Some shots were straightforward, such as dividing and replanting bulbs, planting bare-root roses, and preparing a bed for perennials, but others were complicated, such as installing a knot garden using herbs, installing various types of irrigation systems, erecting a rose arch, and laying a flagstone path. Not only did each sequence have to show the end result, such as the arbor in full bloom, but they had to be photographed in one season. Normally this would be an impossible task because a full-flowering rose arch can take three seasons to mature. Here's how it was done:

We decided that the only efficient way to work was to shoot all the sequences on our own property, Cedaridge Farm. Searching through our photo file covering 30 years, we selected "end-result" images, such as a rose arbor in full bloom, and then worked back from it to show the step-by-step sequences by installing the identical design. Where we didn't have a good file photo, we drove around the neighborhood to find one. For example, we needed to show a windbreak using evergreen arborvitae, and found a beautiful mature hedge at the side of the road a few miles from home. We then went back and, because we have 25 acres of farm to work with, were able to do the step-by-steps in a location that closely matched the mature arborvitae hedge.

With my wife serving as the model for all the sequences, the project went effortlessly and the results were satisfactory. From the moment the books were published, photography became the norm rather than the exception for step-by-step sequences in similar garden books, replacing artists' renditions.

I took this charming picture of Mrs. Ruth Levitan showing her young granddaughter around the property when I photographed Mrs. Levitan's Connecticut woodland garden for *Architectural Digest*.

News and Public Relations Photography

I'm often involved in meeting with clients to brainstorm press releases and provide newsworthy photographs that editors will use to announce the introduction of new plants, especially flowers and vegetables.

For a new asparagus called "Ben Franklin," we dreamed up the catchy headline "Now, Asparagus as Thick as a Man's Thumb!" to describe the new jumbo variety with three times the productivity of regular asparagus. I then took a close-up of a single spear with a man holding it to show it really was thicker than his thumb. For a new giant cabbage called "Mammoth," I posed my six-year-old son with a prize specimen that appeared to be bigger than he was. And for a new giant-fruited strawberry called "Earliglow" that claimed to grow as big as a peach, I posed the garden-fresh strawberries with some actual peaches purchased from a supermarket.

However, my most remarkable press introduction was a plant called a "Tomato-Potato," involving a tomato plant grafted onto a potato plant. Being in the same family and closely related, the graft could produce tomatoes above ground and potatoes in the soil, all in the same planting space. When the plants were ready to harvest, with lots of red-ripe tomatoes, I gently uprooted the plant to show the potatoes among the roots, and posed

my wife with a trowel to show that these were "big" tomatoes and full-size potatoes. Not only did the picture appear in newspapers and magazines across the country, but it also was a feature of many television news programs.

Legally, a press release can be considered an offer for sale, and therefore a permission form is needed from both the model and the owner of the property you use. Reproduced here is a standard release that can be used to obtain a model's permission. See page 124 for an authorization for publication form.

MODEL RELEASE FORM

To _____

From _____

In consideration of having received a fee of $_____

in return for posing for photographs taken by you on _____ at _____

I hearby assign you full copyright of those photographs together with the right of reproduction either wholly or in part for editorial or commercial use.

You and your licensees or assignees may have unrestricted use of these for whatever purpose you may think fit, including advertising, with any reasonable retouching or alteration.

I agree that you or your licensees or assignees can use the above-mentioned photographs either separately or together, either wholly or in part, in any way you wish and in any medium.

I agree that the above-mentioned photographs and/or reproductions shall be deemed to represent an imaginary person, and further agree that you or any person authorized by or acting for you may use the above-mentioned photographs, or any reproductions of them for any advertising purposes or for the purpose of illustrating any wording that you or they may decide to be desirable, and agree that no such wording shall be considered to be attributed to me personally unless my name is used.

I also promise that, provided my name is not mentioned in connection with any other statement or wording that may be attributed to me personally, not to prosecute or to institute any proceedings, claims, or demands against either you or your agents in respect of any usage by you or them of the above-mentioned photographs.

I have read this model release form carefully and fully understand its meanings and implications.

I am over 21 ❏ I am not over 21 ❏

If a minor, have parent or legal guardians sign here _____

SIGNED _____

DATE _____

You can earn a good income by selling your work. Even if your intention is not to make a lot of money, lessons learned from seeing your work published, and the immense satisfaction you feel at having your work accepted, are worth more than the modest fees usually paid for flower and garden photography. Let's deal here with organizing your files, labeling, storage, presentation, and marketing. I'll talk more about the economics in the next chapter.

Know Your Rights

Gardens, both private and public, cannot be copyrighted, so there is nothing to prevent you from photographing a garden and publishing your photos for payment—providing use is editorial, informational, or educational. This means non-commercial usage such as newspaper articles, magazine features, book and calendar publication, greeting cards,

(Opposite page) It's fun to use part of your income from selling garden photography to travel to other countries, seeking both private and public gardens, or to be sent on assignment by publishers and advertisers. The Moroccan Tourist Office provided me with a guide for a week to photograph the gardens of Morocco, including the Marjorelle Garden, in Marrakech on the edge of the great Sahara Desert. The garden features mostly drought-tolerant plants, such as this magnificent specimen of agave.

These are some of the recent books, calendars, and magazine covers featuring my flower and garden photography. The wall calendar, *Great Gardens*, is now in its 15th year of continuous publication. The Monet Museum purchased 3000 copies of my wall calendar, *Secrets of Monet's Garden*, as a special memento to sell in its gift shop. Be sure to examine magazine covers before submitting selections. Will your images accommodate the title and other type headings? Do the publications prefer close-ups? Do they want people in the pictures?

CD-ROMs, lectures, and the like. Indeed, the freedom to publish photos of gardens includes most uses—except advertising, such as in a print advertisement as a background to sell cars, or a billboard to sell allergy pills for a pharmaceutical company.

Some magazines play it ultra-safe and request signed releases when you have photographed a private garden. Most times they will write to the owner themselves, but in the United States, photographers enjoy a great deal of protection under the First Amendment that guarantees freedom of the press.

Some public gardens prohibit the use of tripods on the property, which is their right because a tripod can be a nuisance in a public place, and can damage valuable plantings. Some public gardens even charge a fee for the use of a tripod and any other special professional accessories, such as models, ladders, windbreaks, and lighting generators, but they generally have no right to request a fee when you can simply aim and shoot.

If you ever receive a request to use a garden photo commercially, usually through an advertising agency, it is then necessary to request permission of the owner. A suggested standard permission form follows on page 124.

AUTHORIZATION FOR PUBLICATION

Permission is granted to _____

<div align="right">*Name of Photographer*</div>

to publish photographs and text of the garden/residence _____

<div align="right">*Name of Owner*</div>

Address City State/Province Country Zip/Postal Code

The garden/residence to be published was photographed by _____

<div align="right">*Name of Photographer*</div>

Views of architecture, garden scenes, and decorative features may appear in the pictures.
If the owner wishes to remain anonymous, please indicate by checking this box: ❏

Signature of Owner Address City State/Province Country Zip/Postal Code

Date

(check one) ❏ Editorial ❏ Commercial ❏ Both

Correct Identification

Apart from taking quality plant pictures, the most important step toward selling your work is correct identification of your subjects. Nothing irritates editors more than receiving batches of slides with no information about what they show, or incorrect information. I once saw a slide of Swiss chard used to illustrate an article on rhubarb—a slip caused by an error on the part of the photographer!

When you take a plant picture, identify it accurately. As a bare minimum, you should provide the botanical name and the common name, and your name and address as the copyright owner. If it is illustrating a garden, it should name the garden and the plants that can be seen in the composition. It is absolutely useless to label slides "red apples" or "white tulips." A good tulip identification, for example, would be *Tulipa fosteriana "Red Emperor."* In parentheses, give the common name Tulip, "Red Emperor." Also provide a number that can be cross-referenced to a log giving more information than the slide provides. In the case of garden scenes, include time of year, location, and a general description such as *456234 Bodnant Garden, near Welshpool, North Wales. Yellow Rhododendron calendulaceum and*

Rhododendron "Sappho" with red-wood trees and mill stream in Valley Garden. May 1999. Then, if a slide is lost, all you need is the number to make an accurate identification.

Usually it is not difficult to obtain the correct identification in botanical gardens and arboretums because specimen plants typically are identified. If they are not labeled clearly, ask a gardener or superintendent. If that fails, go to a good reference library—or onto the Internet—and search. If you still draw a blank, a local horticultural society may be able to refer you to someone knowledgeable enough to help. Some institutions, such as botanical gardens, will even provide an identification service. At Harvard University's Orchid Herbarium, for example, a staff botanist identifies flowers using a collection of 100,000 preserved specimens and 5000 library volumes for reference.

Be warned, however, that not all reference books are accurate in their representation of plants. I counted more than 20 errors in naming varieties, even mis-naming edible oxalis as okra in a popular identification book devoted to vegetables! The books I rely on for good identification are the *A-Z Encyclopedia of Garden Plants* (Dorling Kindersly) and *Exotica* by A. B. Graff. For proper nomenclature, I also use *Hortus* a great deal. Edited by the staff of the L. H. Bailey Horatium, Cornell University, it has no photographs, but it does have the advantage of showing where two plants might have two different Latin names, and which is the correct choice.

The ultimate reference book for plant photographers has not yet been published. It would have the listings and descriptive content of *Hortus* and color photographs similar to the *A-Z Encyclopedia of Garden Plants*. Until that day arrives, I regret you will have to use a number of sources to identify plants correctly.

Filing

While you are building a collection of quality pictures and identifying them correctly, the next most important consideration is a sensible filing system so you can retrieve images quickly when you receive a request. With my system, every slide is given a number and a detailed description, and the information is entered into a computer file. I use Latin names for the main identification, but the label also lists the common name. Fruits and vegetables are an exception: These are filed by common name because rarely are they requested by Latin name. The file is separated into major categories in the following groups because this is how most publishers request them:

Annuals
Perennials
Bulbs
Fruits & Vegetables
Herbs
House Plants
Trees & Shrubs
Wildflowers
Roses
Orchids
Cacti
Gardens—by name or name of owner
Structures—design features such as steps, walls, and gazebos
Miscellaneous— mostly pests, diseases, step-by-step sequences

I remove all 35mm slides from their mounts and file them, as well as my 2-1/4-inch transparencies, in individual transparent sleeves. This makes them easier to store, ship, and view. A label at the top of each sleeve shows the number and other pertinent information. The number alone can be entered into my computer. When a shipping form is needed, it requires only the number to be typed for the computer to print complete descriptive information, including whether it is a close-up, specific view, or overall view, although swiping the label through a barcode reader would be faster. Tracing the slide is done by simply entering the number.

An excellent photo management software program, Pro-Stock (20/20 Software, 2001 West Main Street, Stamford CT 06902), provides all the necessary functions to manage day-to-day operations of a picture library. Also, word-processing programs such as Access and Paradox can be used to organize, track, and retrieve information.

Presentation

How you present your work to prospective buyers is important when you are in competition with other photographers. Unprotected color transparencies collect dust easily and pick up ugly fingermarks and scratches that can render them useless for publication. Transparencies are not the easiest objects to handle-even in 35mm slide mounts—so transparent protective sleeves are vital.

There are transparent sheets for holding mounted 35mm slides, but because some of these have 24 pockets, it's not an efficient bulk

storage method. A better approach is to store and ship slides in individual transparent sleeves. Remove slide mounts and discard them because they take up too much room.

You can buy "glassine" paper envelopes to hold individual color transparencies, but I dislike this type of enclosure. Although you can see through the envelope to identify the subject matter, editors must remove the picture to see clear details such as sharpness and color quality. Removal of the transparency is unnecessary with my homemade sleeves, which are made from 2-1/2 x 3-1/2-inch (6.5 x 9 cm) transparent sleeves manufactured by Eastman Kodak (available through Kodak dealers in boxes of 100: Kodak Transparent Sleeves, Cat. #152 3232 for 35mm, and Cat. #152 3240 for 2-1/4-inch). I keep all 35mm and 2-1/4-inch slides unmounted in individual sleeves, with an Avery label at the top identifying the image and showing my name as the copyright owner. I seal the bottom with a clear self-adhesive Avery wafer seal so the slide will not fall through. This type of sleeve protects the film and allows viewing without removing the slide— yet it is easy to remove the film for scanning.

Homemade Transparency Sleeves

I use Kodak transparent sleeves to protect both 35mm and medium-format slides, and to make it easy for editors to view the images. I place a self-adhesive Avery address label at the top, with identification and copyright line, and close the bottom of each with a wafer seal. The slides are protected, easy to view, and accurately labeled, plus store easily in file drawers, and are easy to ship.

This is an example of how I label transparency sleeves:

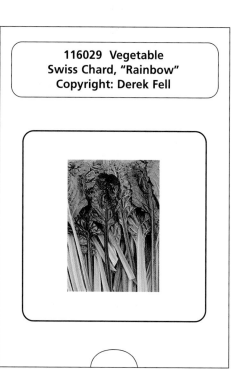

116029 Vegetable
Swiss Chard, "Rainbow"
Copyright: Derek Fell

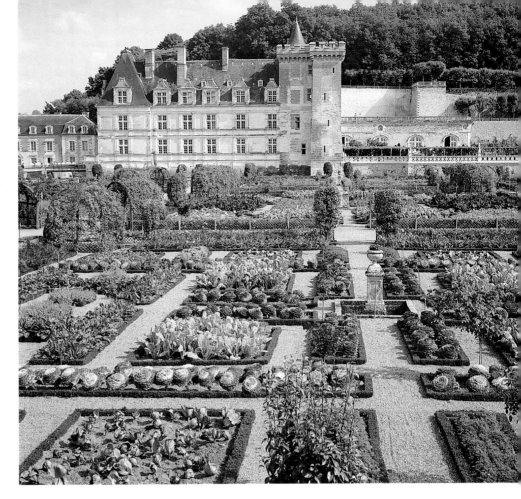

During an assignment for the French Tourist Office, I visited gardens in Provence, Brittany, Normandy, and the Loire Valley, where I photographed the elaborate parterre gardens of Villandry. Unlike other French chateaux that use flowers for pattern effects, Villandry uses vegetables. I have visited Switzerland on assignment for KLM Airlines to photograph alpine meadows, and traveled for the tourist offices of Rio de Janeiro, Hawaii, South Africa, and New Zealand to photograph gardens.

Marketing Your Photographs

Once your work is correctly identified, filed, and protected, and ready for presentation to prospective buyers, you must decide what your best markets are. Some photographers only want assignment work. This means that they don't bother with maintaining a stock photo library, and only work with publishers on specific assignments, negotiating a "day rate" for shooting mostly gardens or product shots. Other photographers take on assignment work as well as build a stock photo library. A few offer only stock images, and do not want the responsibility of assignment work, but this is an expensive way to operate because it means that you pay for all your travel and expenses yourself, while assignment work provides opportunities to build an image library at another's expense.

Most photographers want to deal with magazines and book publishers because they are steady users of images showing both specimens and gardens.

• **Garden Magazines:** At one time, I can remember when there were only three garden magazines consistently using color photography: *Horticulture, Flower & Garden,* and *Organic Gardening.* They are all still with us, but they have a lot of company. Today there are at least 25 published in the United States, with others in Canada and Great Britain. Some are broad in their appeal, such as *Easy Gardening,* published by Family Circle, and *Birds and Blooms,* while others are narrow in their focus, such as *Water Gardening, Wildflowers Gardens,* and *The Herb Companion.*

When photographing gardens for publication, don't concentrate only on floral beauty. Look for design details that combine both plants and structural elements, such as this beautiful path in the Japanese garden of Swiss Pines, near Philadelphia. Note how a rain shower made the stones shine, creating a more appealing picture.

The mail-order market is highly specialized in its needs. They want pictures depicting flawless, picture-perfect specimens loaded with blooms, and generally prefer a vertical format.

Garden magazines are the most consistent users of horticultural photography. Their requirements generally involve specimens, step-by-steps and gardens—especially private gardens that are little known or have not been published previously. Although much of their photography is published through assignment, a good deal is purchased as stock.

Before submitting any work for review, study each magazine carefully to see what types of pictures they prefer. Some, for example, use a lot of step-by-step sequences, such as building a water garden, while others want garden scenes without people.

To introduce your work to a magazine editor, write a letter accompanied by a small selection of your work, carefully identified. Include postage and a self-addressed envelope for the return of your work. In deciding what work to send, look ahead three to six months at what the editor would be planning. For example, in early summer, send images of leaf colorings, chrysanthemum displays, or fall garden scenes using ornamental grasses. You might be fortunate to send something the editor needs at that moment, and your chances of a sale first time are improved greatly.

Don't be disappointed at some of the reactions you may receive. Some editors will return your work with an impersonal rejection slip. Others may take the trouble to explain why they are rejecting your work, and some may even offer you encouragement by suggesting ways you can improve your chances of publication.

• **General Magazines:** Many general magazines include garden or gardening features, and are open to submissions. I have had speculative work published in *Architectural Digest*, *The New York Times Magazine*, *Woman's Day*, and *Elle Decor*. Major features in these magazines usually are purchased on assignment, but you can sometimes be lucky with a speculative submission. Once an editor knows your work, a query letter with an outline of what you propose to send often will suffice to determine interest.

• **Book Publishers:** Publishers handling garden and educational books use a lot of plant pictures. Requests for pictures in plant encyclopedias can run to thousands of images. Usually, the biggest demand is for "specimen" pictures showing flowers and part of the plant in a garden setting. Also needed are garden scenes showing plant categories for "chapter openers," such as a desert garden for a chapter on cacti, a woodland garden for one on shade plants, or an orchid display in a conservatory for a chapter on orchids.

Book publishers often are slow in making selections, and most do not pay until the project is finished or the book published.

Many garden books sold in the United States are actually published in foreign countries, particularly Great Britain, so foreign publishers of garden books are potentially good markets as well.

• **Mail Order:** At least 100 companies in North America publish full-color mail-order catalogs, some dealing wholesale and others retail.

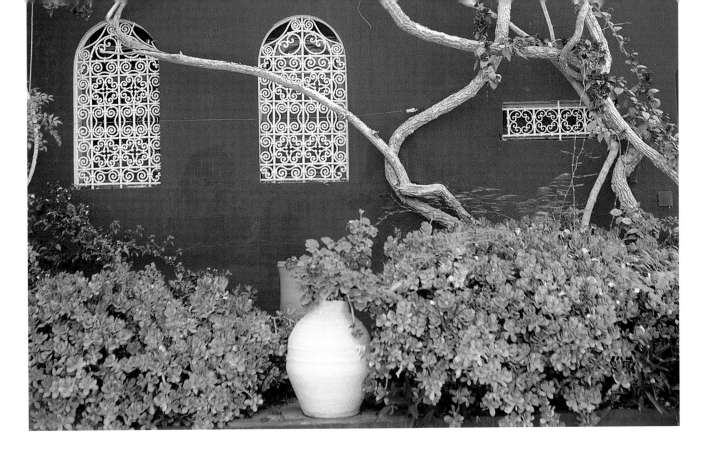

Many are seed companies offering packets of mostly annuals and vegetables, and others are nurseries offering mostly perennial plants, trees, and shrubs. There are also specialist houses dealing in a particular plant group—water plants, roses, and peonies, for example.

A good way to break into this market is to examine a catalog and mark the poorest pictures. Then send new images for all the pictures you feel need improvement, timing your delivery to arrive at least six months ahead of issue (most catalogs are mailed the first week after Christmas).

The mail-order market is highly specialized in its needs. They want pictures depicting flawless, picture-perfect specimens loaded with blooms, and generally prefer a vertical format. With seed companies, because the biggest-selling varieties are mixtures, it is imperative to show a broad range of colors. The best way to achieve this is to arrange the flower heads close together on plain or foliage backgrounds, with the flowers in the same plane so they are all in sharp focus. Generally, flowers should be perfectly symmetrical, uniform in size, and blemish-free.

There is also a demand for "borders" of a particular flower or mixture, such as an aster border or zinnia border. Because wind and inclement weather often produce gaps or imperfect plants, and there are other hazards such as pests and diseases, it's often difficult to find a good-looking border outdoors. Rather, it is best if the individual colors are grown in pots in a protected environment, such as a cold frame or greenhouse, and then arranged as a border, diagonally for the photo.

To find good catalog subjects, in addition to growing your own, visit test gardens at state universities and botanical gardens.

The garden of Marjorelle, in Marrakech, Morocco, is owned by French fashion designer, Yves Saint-Laurent. The genius of its design is evident in the choice of colors for walls and other structures: a deep blue matching the color of a Saharan sky at twilight, and gold, the color of desert sand.

When I photographed Renoir's Garden in the South of France for my book *Renoir's Garden*, I spent days photographing nothing but its grove of olive trees. Renoir liked the old trees for their near-human characteristics, but for the whole time I had nothing but cloudless blue skies that thwarted creative photography-until I encountered these two grand old specimen trees evenly lit by a muted, early-morning sunrise. Using a telephoto lens to eliminate extraneous background, I created an image that resembles a supernatural forest scene from Tolkien.

• **Seed Packets and Plant Labels:** Seed packets and plant labels are printed every year, and the printers are always seeking good images to replace over-used or "dated" images. Image choice may be controlled by the seed or plant company, or sometimes by the printer. Some printers have their own photographers, but others rely on freelance submissions. Every year I deliver hundreds of images to one printer for use as seed packets, working from a list he supplies. It's an on-going process because each year plant breeders introduce new varieties to the market.

Generally, seed packets and plant labels are either flowers or vegetables, although herbs and fruits are also in demand. With vegetables, the biggest demand is for "on-the-vine" images, such as tomatoes clustered on a branch, or showing a suggested use, such as sweet corn freshly cooked ready for eating, covered with a dab of butter. Many herbs are unattractive as garden plants, but it is surprising how attractive they can look in decorator pots and arranged in a kitchen setting, pairing the herb with its most common use, such as mint with a cup of mint tea. The most desirable format for seed packets and labels is vertical.

• **Calendars and Greeting Cards:** The leading calendar company, Portal Publications, produces more than 100 calendars annually. Three of them are mine: *Great Gardens* and *Secrets of Monet's Garden* are wall calendars, while *In the Garden* is a desk diary. I first started working with Portal when they invited me to submit for a garden calendar featuring the work of several photographers. The next year I was offered the project solo and, in spite of calendar subjects coming in and out of fashion, *Great Gardens* is in its tenth year of publication, earning an advance plus royalties.

To get started, write to several calendar companies of your choice and request their submissions form. This will arrive with clear instructions about what types of images they seek, and the subject categories. For a rainforest calendar, they may specify special regions of the world: Fiji, New Zealand, Hawaii, or Costa Rica, for example. For an orchids calendar, they may want only close-ups of certain varieties.

The submission form will also state what format is needed—usually square or horizontal—and what film size-usually 2-1/4-inch or larger.

Greeting-card companies sometimes have a calendar line, but many do not. The procedure for breaking into this market is the same as calendars: Write for a submissions form to determine the kinds of images the company is seeking. Years ago, the demand was for "soft-focus" effects, but more recently they request artistic compositions using special lighting qualities and atmospheric effects. Flowers, seasonal wild landscapes and "country" images of harvest scenes such as pumpkins and old barns are in constant demand.

• **CD-ROM and Digital Sales:** I have supplied images for CD-ROMs produced by Microsoft, *Sunset* magazine and Lifestyle-Software. In the case of Microsoft and Lifestyle-Software, they preferred Ektachrome 64 film because their scanning process turned the greens of other films almost black. Microsoft and *Sunset* used my images with other photographers, but in the case of Lifestyle-Software, I was the sole supplier of more than 2500 images. The product, The Gardening Companion, received a top rating of four stars from CD-ROM magazine. In all cases, the software companies wanted original slides.

However, there is a strengthening market for digital images. Clients like them supplied on disks containing specific topics such as perennials, annuals, or bulbs; or over the Internet for downloading from a website. It's a good idea to have a website, which you can create using software provided by many Internet Service Providers (ISPs). On the site, describe the types of images available and show low-resolution samples of your images. In my experience, a lot of downloading from the web is done by advertising agencies and marketing organizations that use the images for rough layouts; they then often request original color transparencies.

The British Isles offer tremendous opportunities for garden photography. One of my favorite public gardens is Hodnet Hall in Shropshire—especially in early summer when this large bog garden begins to flower with drifts of perennial astilbe, framed here by the branches of surrounding trees.

• **Stock Photo Agencies:** A number of stock agencies such as *The Garden Picture Library* in the United Kingdom and *Armstrong Roberts* in the United States maintain extensive stock photo files and supply a range of pictures to publishers, advertising agencies, and catalog houses. Many professional plant photographers with little time to maintain their own stock files contribute their work to stock agencies, and usually receive 50% of any publication fees. Each agency works differently, so ask for their submission terms before sending any work.

• **Slide Lectures:** There is a modest demand among schools, garden clubs, and other educational organizations for 30- to 60-minute slide lectures containing from 50 to 100 duplicate 35mm color slides numbered to match a script. The person renting or buying the slide lecture simply inserts the slides into a projector and reads the script in synchronization with the slides. Some popular slide lectures include "Garden Designs Using Perennials," "Shade Gardening Ideas," and "How to Plan and Plant a Water Garden." Typically, these are rented for a set fee. A way to market them is through the classified sections of gardening or educational magazines.

I have never rented slide lectures with scripts, but I have several slide lectures that I present myself as a speaker at flower shows and garden clubs. The most popular are "Great Gardens of the French Impressionist Painters," which drew an audience of 700 when I presented it to the Grand Rapids Botanical Garden; and "Cedaridge Farm Through Four Seasons," which presents the design philosophy and planting of my own garden in Pennsylvania. Fees depend on the recognition of the lecturer and range from $100 for a local show to $5000 when you are billed as the "keynote" speaker for a big function.

• **Prints and Posters:** Many greeting-card and calendar companies produce posters for framing and sale through mass-market outlets. Usually the selection is done by art directors who see a published photograph in a magazine, book, or calendar and want to make a poster of it. I have had several posters published through Portal Publications, mostly as a result of images in books: "Deerfield Garden" features exquisite lake reflections in spring with a family of geese at the water's edge; "Woodland Garden" features a small pool surrounded by early spring flowers and flowering shrubs; "Monet's Bridge" features the Japanese bridge covered with wisteria against a misty background. Another company chose "Renoir's Studio," showing the painter's painting paraphernalia with roses, and "Gardening Tools," showing an assortment of garden tools and plants arranged on a porch.

Wall art of signed, limited-edition prints can be sold through galleries, but this is a difficult market to break into and sales are not great. I sell several hundred images a year through a gallery at my home, purchased mostly by visitors to the garden. The most popular images are "Carolyn's Cottage," showing my wife's garden studio shrouded in mist and encircled with flowers; "Lavender Farm," showing a lavender field in Provençe; and "Renoir's Garden," showing two ancient olive trees in early morning light.

Holland is especially beautiful in spring, when gardens are filled with flowering bulbs. The private garden of artist Ton ter Linden is at its best in late summer when summer-flowering perennials are used in combination with grasses to "paint" the landscape in an Impressionistic style.

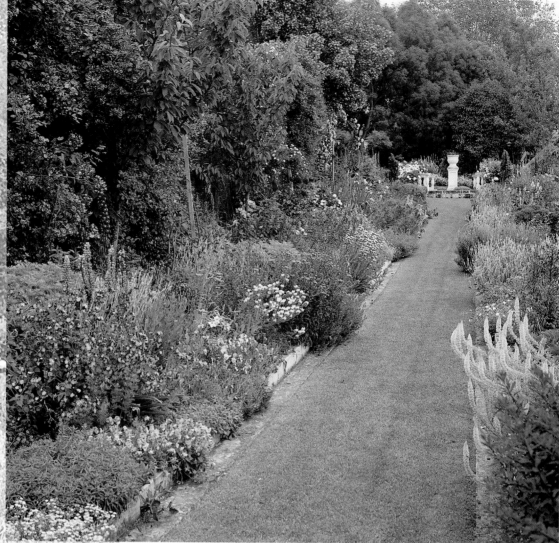

I have found the best outlets for horticultural photography to be book publishers such as Houghton Mifflin (publishers of the Taylor series of garden books), garden magazines (such as *Horticulture* and *Garden Design*), calendar and greeting-card publishers (such as Portal Publications and Avalanche), seed and nursery companies (such as Burpee Seeds and Gurney Seed & Nursery Company), and color-packet printers (such as Cambridge-Pacific).

Wish Lists

Publishers typically send out "want lists" or "wish lists." Sometimes they are specific, listing plants by botanical and common name, and stating what types of images are required, such as garden scenes versus specimen shots. When a list seems vague, call the photo editor and request clarification; there is nothing more infuriating than spending several days choosing slides for a big project, only to discover that all the images have to crop to a horizontal format, or show plain backgrounds. Sometimes these wish lists will dictate

The photographs on these two pages are of the same property: a spacious garden near Oamaru, New Zealand called Parkside, designed by owner Linda Wilson. A beautiful feature of Linda's garden is a double perennial border with a pedestal in the background, and a grass path dividing the beds.

terms you may not be comfortable with, such as payment on publication, no search fees, no holding fees, or fees that are too low. Often, these terms can be negotiated, depending on how good a reputation you have built.

When Teamwork Pays Off

No two publishers work alike. Some make a lot of work for themselves because they have no idea how to work efficiently with photographers. For example, when a publisher produces a heavily illustrated book, he usually works with a horticultural consultant who comes up with lists of plant varieties. The art director or picture editor then has to search for pictures to match the lists. How much easier and less expensive it would be to first consult with photographers to find out what images are available, and then make up the lists. After all, when images cannot be found after extensive searching, substitutions must then be made.

Every photo feature of a garden should show the owner or owners. To capture Linda in a casual pose, I invited her to sit on a balustrade in a "romantic" part of the garden planted predomantly with white flowers.

For a CD-ROM project involving 2500 slides, I was given broad categories of photography needed: 500 annuals, 500 perennials, 250 shrubs, 250 trees, 100 bulbs, 100 roses, 100 vegetables, 100 herbs, 50 fruits, etc. Within a week, I had all the material assembled. A writer then set to work collating data to match my slides. Trying to do the project in reverse might have entailed months of work.

Negotiating Prices & Rights

Rates of pay for photography, and opportunities for credit vary significantly. Usually, the higher the circulation, the better the rate. Also, rates will depend on whether the image is used small, such as 1/4 page or less, or large, up to a double-page spread. Covers, chapter-openers, and back covers also command higher rates. Most publishers have a set rate of payment; others will ask for your price. Good guides for stock picture rates are available from Fotoquote (Box 1310, Point Roberts WA 98281) and Jim Pickerell (110 Frederick Avenue, Rockville MD 20850).

Most publishers have a set rate of payment; others will ask for your price

Two views of the same area, one showing an overall view (above), and the other a specific view of a bench with a cat figurine.

One of the advantages of having a garden of your own is that you can create photogenic spaces. Then it is easy to shoot in different seasons and under different lighting conditions. Here's a rose arbor at Cedaridge Farm in spring, and the same area in winter.

Some publishers try to purchase "all rights." Generally this is a bad policy for the photographer unless the work has been commissioned as an assignment, with all expenses paid, including travel, hotel, meals, and film. Even then, it is better to retain the rights to "out-takes" (any images not published).

Most professional photographers make it a policy not to sell all rights to "speculative" work—images created independently. In this case, the rights sold typically are very specific, such as "one-time rights for publication in XYZ magazine." Then, if the publication wants to use the image on a website or in a subscription mailer, an extra payment is required. Some publishers pay on acceptance, others on publication. Some pay automatically, others require an invoice.

Copyright protection for photographs varies according to the country in which you sell your work. In the United States, the photographer has automatic copyright protection unless he chooses to sign away those rights, or if a contract exists with a publisher stating the photographs are the result of a "work for hire" agreement.

The automatic copyright protection provided by law is limited and requires the copyright infringer to make only reasonable compensation. To claim punitive damages—an additional amount imposed as a "punishment,"—images must be filed with the Copyright Office. This requires completing a form, payment of a modest fee and a copy of the image. In the case of photographs, the Copyright Office accepts multiple images for protection under one filing fee. It's a chore when you are shooting thousands of images a year, so few photographers selling stock images ever go the extra mile to protect their work in order to collect punitive damages.

In 30 years of selling tens of thousands of photographs, I have experienced only two cases of a clear and blatant breach of copyright. However, legal costs to pursue the issue, and the time required if the infringer decides to contest the case, do not justify the trouble of registering slides with the Copyright Office, in my experience. (To obtain copyright forms, contact: US Copyright Office, Library of Congress, Washington DC 20559.)

Generally, gardens are extensions of the house, so it's good to seek views that show the garden in relation to the residence. I was struck by the impressive architectural lines of a Victorian-style conservatory at Bodnant Garden, so I composed a view from the garden that combines three strong elements: a healthy clump of dark blue iris, a stone balustrade, and the historic conservatory.

An advantage of selling work for book or magazine use is the publication of a credit line. This can help generate more business. A caution: When you initiate an article on the basis of your photography, and the magazine assigns the text to a writer, be sure you receive equal or better credit than the writer and not just a tiny credit beside the pictures!

Also be wary of "filling holes." In some cases, a book may be using another photographer while your work is used to fill gaps—yet the other individual's work is given "preferred photographer" credit.

Search & Shipping Fees

Maintaining a photo file can be costly. My photo library occupies a separate building, with an office manager and an assistant labeling, filing, making shipments, keeping track of submissions, logging returns, invoicing, and other administrative chores. Because office overhead is significant, to discourage frivolous requests, I bill for search and shipping fees. Whether to impose them has to be weighed with each submission. When you are recognized as a stock agency, publishers normally are willing to pay for the time of putting together a submission.

Lost Slides

Some publishers can be careless about returning slides. Photographers have been able to collect as much as $1500 per lost image! Normally, when slides are lost, the culprit will call to offer a settlement at much less, but this is a judgment call you have to make with each incident.

Never submit anything without an enclosed shipping form that details your terms, describes each slide submitted and declares the amount of compensation required in the event of lost or damaged images. Packages should be shipped using a service that requires the recipient's signature to prove delivery.

When slides are returned, they usually come back in batches: an immediate return of rejects; a later return of slides "held for further consideration," and a final return of used images. Check them off the shipping form at each stage. When a publication holds materials for 60 days, send a reminder requesting a status report.

When photographing people in the garden, I like their clothing to be color-coordinated with their surroundings. This image of my daughter, Vicki, picking lavender in one of the herb gardens at Cedaridge Farm, shows her in a summery dress of lavender tones to echo the lavender flowers.

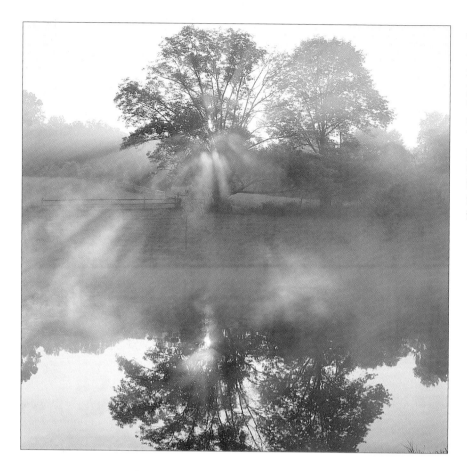

Your garden photography is unlikely to win awards unless you include images that show fleeting atmospheric conditions; after all, it's relatively easy to photograph gardens under bright skies or cloud cover. This image from an award-winning photo feature of a neighbor's garden shows a white oak with early morning sunlight creating shafts of light through its branches, and penetrating mist rising from a pond.

Assignment Work and Travel

It pays to travel. Each year I try to visit a different part of the world noted for beautiful gardens. Fortunately, I live in an area of the country, the Delaware Valley, which has a rich heritage of gardens, both public and private. Within an hour's drive of my doorstep are many places to obtain salable pictures year-round. Other areas of North America where I have found rich pickings are Savannah, Georgia; Charleston, South Carolina; coastal Massachusetts and Maine; Carmel, California; Portland, Oregon; Hawaii; and New Orleans for courtyard gardens.

Some of my favorite foreign destinations include Scotland, North Wales, Japan, Taiwan, Vancouver Island, France, Brazil, Morocco, South Africa, Holland, and New Zealand. Sometimes I travel at my own expense, but often I can obtain an assignment or a sponsor. For example, I have twice visited Bermuda and the British Virgin Islands, also Hawaii, on assignments where I was paid for 2-1/2 days of travel time and shooting, plus all expenses.

On other occasions, I have been the guest of various travel authorities, including the New Zealand Tourism Board, the British Travel Authority, the Moroccan Tourism Office, and the French Government Tourist Office. Sometimes these trips have been solo, with a rental car provided for ten days of travel paid for by the tourist authority. Other times, trips have been with groups of other journalists on "familiarization" trips, with a driver and guide provided by the host country.

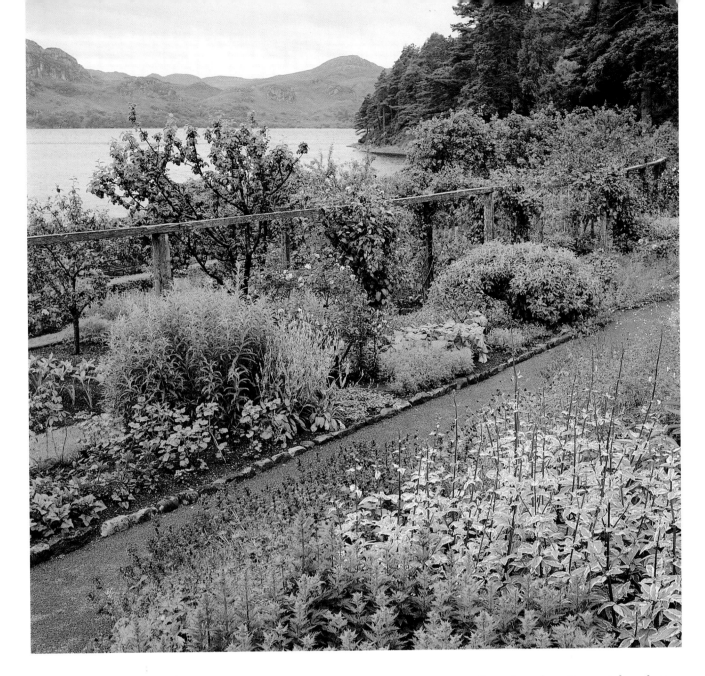

Professional Associations

Two invaluable professional associations are the Garden Writers Association of America (GWAA) and the Society of American Travel Writers (SATW). Membership in GWAA is easy: You do not even need to be published. Through their newsletter and regional meetings, GWAA brings you into contact with other people who share your interests.

The SATW is more difficult to join because you must prove a consistent amount of travel writing or photography. An advantage of membership in SATW is not only the newsletter and meetings, but the number of familiarization trips offered to members by tourism offices, with the specific aim of having landscapes and gardens photographed for publication.

Write for membership application forms to: Garden Writers Association of America, 10210 Leatherleaf Court, Manassas VA 20111; Society of American Travel Writers, 4101 Lake Boone Trail, Raleigh SC 27607.

One of my favorite coastal gardens, because of the opportunity to photograph its large terraced vegetable/perennial garden in close proximity to the sea, is Inverewe, on the rugged northwest coast of Scotland.

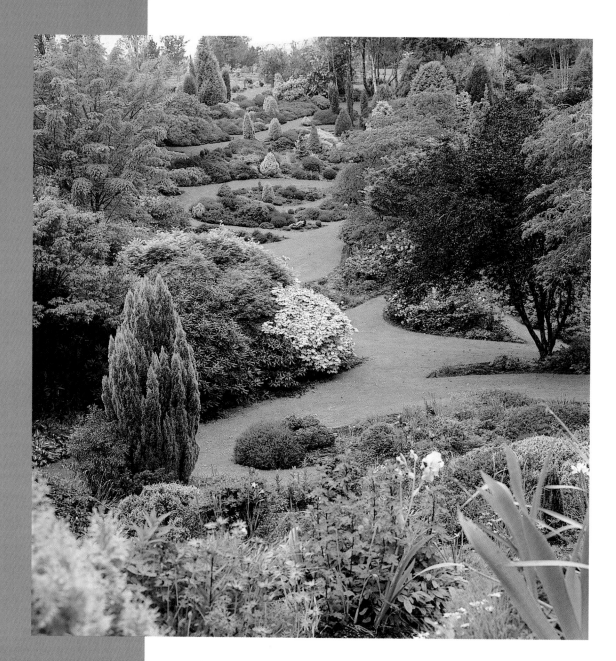

Appendix

There are many ways to learn more about equipment that can be used to create the types of images you see in this book. You can read more of the Silver Pixel Books that cover specific camera lines, and others teaching about photographic technology and techniques. They are available at your local camera store or, for a catalog, contact:

Silver Pixel Press, A Tiffen Company
21 Jet View Drive, Rochester NY 14624.

Most of the photographic magazines available on the newsstand offer hands-on discussions about photographic flowers, plants and landscapes as well. In these publications, you will find advertisements from major manufacturers, which include an address and telephone number to request additional information.

The most up-to-date information available will be found on suppliers' web sites. You can use popular search engines to locate companies' sites on the Internet. Here is a sampling of some of the photographic suppliers that offer quality products; this is not meant to be an all-inclusive list:

Agfa film: www.agfaphoto.com
Bronica cameras: www.tamron.com
Camera accessories: www.tiffen.com
Canon cameras: www.usa.canon.com
Contax cameras: www.contaxcameras.com
Fuji cameras and film: www.fujifilm.com
Hasselblad cameras: www.hasselbladusa.com
Kodak film: www.kodak.com
Leica cameras: www.leica-camera.com
Mamiya cameras: www.mamiya.com
Minolta cameras: www.minoltausa.com
Nikon cameras: www.nikonusa.com
Olympus cameras: www.olympus.com
Pentax cameras: www.pentax.com
Rollei cameras: www.rolleifoto.com
Silver Pixel Books: www.saundersphoto.com

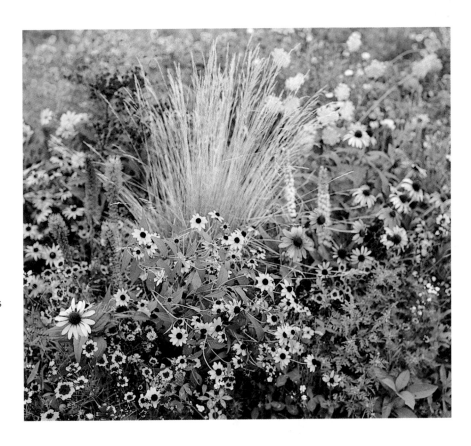

There is a big push to plant gardens with "native" varieties because so many introduced plants have started to crowd out native species. To satisfy a demand for "prairie gardens," I planted this space at Cedaridge Farm, placing late-blooming perennial plants around a clump of prairie grass.

Cedaridge Farm has two large meadows for growing an assortment of native North American wildflowers. This corner of my meadow was captured on a misty morning, with purple ironweed and yellow swamp sunflowers blooming together.

Visiting Cedaridge Farm

Derek Fell's photography garden can be visited without appointment during two weekends each year, around Mother's Day and Father's Day. Call 215.766.0699 for directions or follow garden signs from the Piper's Tavern, Pipersville, Pennsylvania. There is no entrance fee.